TOO MUCH MIDNIGHT

THE BREAKBEAT POETS SERIES

The BreakBeat Poets series is committed to work that brings the aesthetic of hip-hop practice to the page. These books are a cipher for the fresh, with an eye always to the next. We strive to center and showcase some of the most exciting voices in literature, art, and culture.

The BreakBeat Poets Advisory Board:
Kevin Coval (Series Editor), Nate Marshall, Idris Goodwin,
José Olivarez, Safia Elhillo, Maya Marshall, and Mahogany Browne

BREAKBEAT POETS SERIES TITLES INCLUDE:

The BreakBeat Poets: New American Poetry in the Age of Hip-Hop, edited by
Kevin Coval, Quraysh Ali Lansana, and Nate Marshall

This is Modern Art: A Play, Idris Goodwin and Kevin Coval

The BreakBeat Poets Vol 2: Black Girl Magic, edited by
Mahogany L. Browne, Jamila Woods, and Idrissa Simmonds

Human Highlight, Idris Goodwin and Kevin Coval

On My Way to Liberation, H. Melt

Black Queer Hoe, Britteney Black Rose Kapri

Citizen Illegal, José Olivarez

Graphite, Patricia Frazier

The BreakBeat Poets Vol 3: Halal If You Hear Me, edited by
Fatimah Asghar and Safia Elhillo

Commando, E'mon Lauren

Build Yourself a Boat, Camonghne Felix

Milwaukee Avenue, Kevin Coval

Bloodstone Cowboy, Kara Jackson

Everything Must Go, Kevin Coval, Illustrated by Langston Allston

Can I Kick It?, by Idris Goodwin

The BreakBeat Poets Vol 4: LatiNEXT, edited by
Felicia Rose Chavez, José Olivarez and Willie Perdomo

TOO MUCH MIDNIGHT

KRISTA FRANKLIN

Haymarket Books
Chicago, Illinois

Published in 2020 by
Haymarket Books
P.O. Box 180165
Chicago, IL 60618
773-583-7884
www.haymarketbooks.org
info@haymarketbooks.org

ISBN: 978-1-64259-130-9

Distributed to the trade in the US through Consortium Book Sales and Distribution (www.cbsd.com) and internationally through Ingram Publisher Services International (www.ingramcontent.com).

This book was published with the generous support of Lannan Foundation and Wallace Action Fund.

Special discounts are available for bulk purchases by organizations and institutions. Email orders@haymarketbooks.org for more information.

Cover artwork by Krista Franklin, "Never Can Say Goodbye,"
appeared on *Unable to Fully California* by Larry Sawyer (Otoliths, 2010)
Cover design by Rachel Cohen

Printed in Canada by union labor.

Library of Congress Cataloging-in-Publication data is available.

10 9 8 7 6 5 4 3 2 1

In loving memory of
Monica A. Hand
(1953–2016)

"Love is or it ain't. Thin love ain't love at all."
—**Toni Morrison**

"Nothing is absolute. Everything changes, everything moves,
everything revolves, everything flies and goes away."
—**Frida Kahlo**

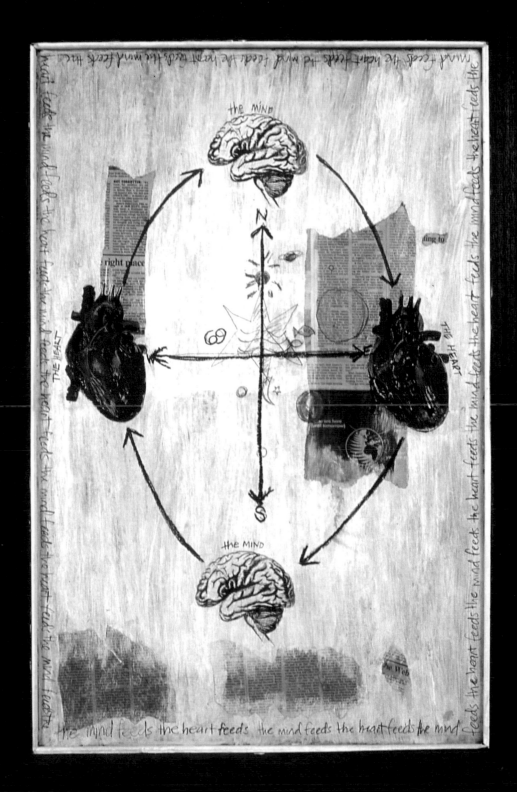

CONTENTS

INTRODUCTIONS

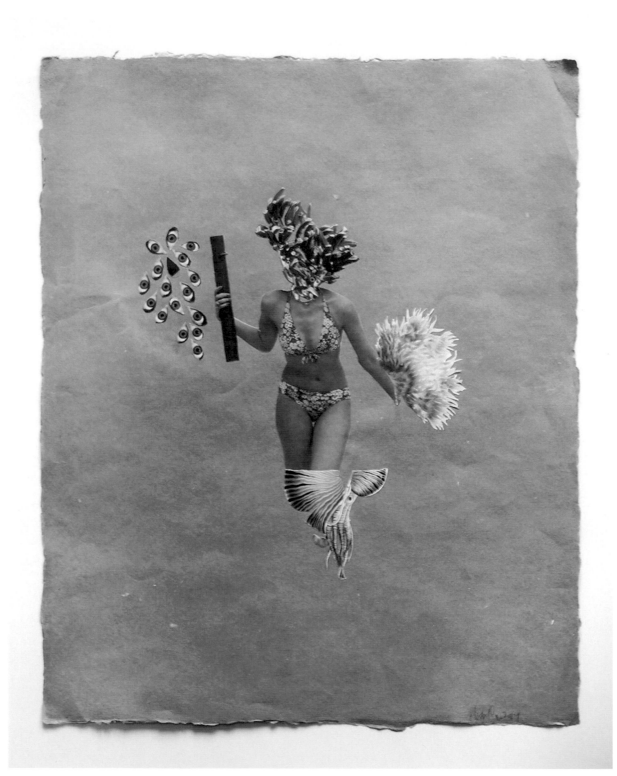

THE BLACKEST, MOST FERTILE MIDNIGHT
Maria Eliza Osunbimpe Hamilton Abegunde

If you are familiar with Krista Franklin's visual and literary works, then you know no space is sufficient to hold the world/womb into which she has invited you. If you are not familiar with her work, then turn the pages. But, "Are you sure, sweetheart, that you want to be well?"[1] If unsure, find "It's the Skin That Tells" or "Black Bullets." Read aloud. Pay attention to what your skin tells you. Breathe. Do not stop breathing no matter the pain or joy you feel in places you have denied fear and desire. And love. Find "Oshun as Ohio Player(s)." Do not turn away from Oshun drinking from her own honeypot: you need this lesson to show you how to find pleasure inside your own wounded, tattered, weary self.

Too Much Midnight is an *ebo*, an offering that is sacrificial, cleansing, transformative.

It is an invitation to be well in parts of your life and body that are dis-eased with the past and hopeful with the future. These are our stories. They are the stories of those who have suffered like us and who chose instead to struggle to be whole without shame. Krista Franklin has called the mothers—ancestral, mythical, and living—because she knows that to be well, to understand that midnight is the hour of simultaneous ending and beginning, requires the renting of veils, the transfiguration of souls. Only (the) mothers can cut you without killing you, stitch you without leaving a scar.

By calling these mothers, Krista Franklin also knows that ". . . when a woman pushes a person out her pussy, it transforms her." But, what happens to her when in her womb exists the cosmos, which she also created; when she gives birth to men, gods, and herself?[2] What happens when a woman understands that her body is the code to eternity, what does the world do with her?[3] When a woman pushes a person / a poem / a book / a river of bliss out her pussy, the blackest, most fertile midnight in the universe, she makes magic, chooses to share it/them with the world.

And, in this world, Black girls are mothers / owners of everything, especially themselves.[4]

Too Much Midnight is a revolutionary vision for peace. In "Call" Krista demands we create new ways of being with ourselves and each other: "If You find Your imagination cannot stop itself from churning out the scripts of the Death Machines, pull its plug . . . Manufacture Daylight. *We* are the Magicians."[5]

In awe-filled gratitude, always.
Ase. Ase. Ase-O.

MARIA ELIZA OSUNBIMPE HAMILTON ABEGUNDE is a memory keeper, poet, ancestral priest in the Yoruba Orisa tradition, doula, and a Reiki Master. Her research and creative work respectfully approach the Earth and human bodies as sites of memory, and always with the understanding that memory never dies, is subversive, and can be recovered to transform transgenerational trauma and pain into peace and power.

She is the author of three poetry chapbooks, including *Wishful Thinking* about the 2001 disappearance of Tionda and Diamond Bradley in Chicago. Anthologized poems are included in *Gathering Ground*, *Beyond the Frontier: African American Poetry for the 21st Century*, and *Catch the Fire*.

1. See *The Salt Eaters* by Toni Cade Bambara.
2. From "Extrapolating Motherhood"; and see *The Architects of Existence: Aje in Yoruba Cosmology, Ontology, and Orature* by Teresa N. Washington.
3. From "Infinity: A Love Poem," in this book, page 49.
4. Washington: "The daughter fresh from the womb is a mother before her own father and grandfather because she holds within her body the forces that ensure continuity."
5. Emphasis mine.

THE ARTIST'S MULTITUDES
Jamila Woods

what did i see to be except myself? | i made it up
—Lucille Clifton

When I first read those lines years ago, I read the second line almost as an afterthought. A stick figure sketch. I imagined someone making herself up as she went, stumbling through the making and not being ashamed of the mess. What does it mean to make yourself up? As a woman? As a Black woman? As a Black woman with a body, with a mother, with shame, with teeth that cut, with a love for funk, etc.?

The Tate Modern's definition, the word *collage* describes both the technique and the resulting work of art in which pieces of paper, photographs, fabric, and other ephemera are arranged and stuck down onto a supporting surface. Krista Franklin introduced me to collage not as only a thing to be made, but as a way of making anything. I go over to Krista's house and she has collaged two recipes of fish stew into one. My friend and I each bring Krista a bouquet of roses and she collages them together in a vase. Krista was my first up-close example of an artist who took a method of creation and applied it to different artistic disciplines seamlessly.

Collage can also be a way of seeing the world, a way of recognizing what has been cut out and what has been pasted in. When Beyoncé's *Lemonade* came out, my cohort and I were geeked and mind-blown. Krista gently treated our lives and wrote the words *Daughters of the Dust* on the board. There is nothing new under the sun—only new minds in our skulls and a responsibility to use our knife to cut a new picture.

Reading this book, I am reminded of the ways in which making oneself as a human and as an artist is a continuous process of collage. Collage involves a choice between what to stick down and what to cut away. Because of this choice, a reclamation of agency is possible. Collage can be a way of remembering, a retelling.

Krista writes, "Depending on the body you live in, history is as slippery as memory." We live in a society where time is constantly wielded as a weapon against marginalized people (i.e. *but slavery was so long ago*, or *why did you wait so long to come forward?* or, simply *wait*.) How refreshing it is to be reminded that time is an illusion, that the past is ever present, to view the body as a collage of what is here and what is remembered. As Black women the stakes of telling our stories are so high. Our narratives are so often contested, doubted, disregarded. So many things are said in hushed voices or never spoken at all. Krista's work grants us permission to contain multiple narratives. Permission to speak things "we never speak of."

To read this book of collected poems and collages is to experience an artist's multitudes in symbiosis. Her words cut. The images speak. The effect is a collage of the senses. The smells in these poems have sounds. Krista's words are set to a metronome. As you read this book, read it out loud. There is an undercurrent of music in every poem, a crate digging that came before every collage.

Krista has been creating across disciplines for many years. Her work has been a model for me and for so many others. Her poetry and visual art have not only influenced my own artistic practice but have also introduced me to other artists, writers, and thinkers in Krista's lineage. I am so excited for this book to be in the world as a synthesis of her many inspirations and modes of creation. When I hear those words by Lucille Clifton I think of Krista, not because she is the original, but because she is the only. She boom. For real. She made it up.

JAMILA WOODS is a Chicago-based American singer, songwriter and poet. Her work focuses on themes of Black ancestry, Black feminism, and Black identity, with recurring emphases on self-love and the City of Chicago.

SOME TRANSBLUESCENT LINEAR NOTES FOR KRISTA FRANKLIN'S *TOO MUCH MIDNIGHT* ALBUM
Greg Tate

> *Where there is a woman there is magic. If there is*
> *a moon falling from her mouth, she is a woman*
> *who knows her magic, who can share or not share*
> *her powers. A woman with a moon falling from her*
> *mouth, roses between her legs, and tiaras of Spanish*
> *moss, this woman is a consort of the spirits.*
> —Ntozake Shange, *Sassafrass, Cypress & Indigo*

Many artists strive to compose works of genuine truth, beauty, and insight, but only a select few provide us with creations consistently imbued with the rara avis properties of Afrocentric conjuration and revelation. Krista Franklin ranks highly among that select few for many of us; one of a magical minority who can do that kind of hoodoo she do in two distinct mediums—the written word and the collage.

When we invoke conjuration as something marvelous at the heart of Franklin's practice we mean to insinuate that here is an artist capable of intentionally producing optical textual wizardry and optical witchery like t'ain't nobody's beeswax if she (repeatedly) do.

As poet and visualist, Franklin casts spells of lyrical legerdemain which mesmerize her readers and viewers before ushering them into her rigorously composed dreamscapes. Works flush with dizzying word-sorcery and eye-popping trans-dimensional portals. The kind of graphic imaginaries that align with Sun Ra's description of realms where Blackfolk could experience soul-resurrecting "altered destinies."

§

Franklin's microverse of references, as writer and collagist, is kaleidoscopic and encyclopedic and oh so very, very Black in its fluent streaming and approximation of the Kulcha's infinite capacity for vernacular renovation, choreographic and sonic regeneration, and a Pan-Afrikanist array of spectacularly singular self-making. Which means Franklin is an adept student and practitioner of creative Blacknuss as a mode of improvisational and imagineering gamesmanship.

Dig on Franklin then as a steady-handed and surgical gamer in stone-cold Cancerian pursuit of self-revelatory marvels. The kind requiring that the artist plumb, scratch, dig, and dive deep into her own well-stocked and voluminously stacked Black interior's archive. *Go there*, retrieve the needed scraps of learned scripture, written, sung, drummed, sprayed, splashed, shot, drawn, blowed, boomed, rhymed, painted, or strummed, which will provide the recombinant DNA helixes necessary to architectonically assemble her art's super-signifyin' matrixes of apocalyptic/prophetic/confessional verse-forms and Astro-Black/Afrosurrealist prayers and provocations. Not to mention her ghostly hand-made paper palimpsests.

Astute readers will quickly note that Franklin often deploys her poem and essay form expressions to delineate her empathic and enraged alarm at the catastrophic assaults which Black folks' flesh, spirits, and psyches have been subjected to over five centuries of rebellion against racially motivated and systemically enabled psychopathy.

The sister's visual conjurations however tend to be more paradisiacal sites of pleasure. Just like the musics of the hyper-erotic and hella-utopic midwestern Funk pantheon Franklin so reveres and frequently enshrines in her practice—cutting, pasting, mixing,

and bombing surfaces until they are precisely laden with her radiant and spectroscopic imagery, lost, stolen, and found.

Too Much Midnight is a long-awaited opus of conjoined miracles for Franklin's cult of long-time admirers, devotees, and disciples. Get entangled in this magisterial tome's many-splendored pages of lucid hypnogagic text and pictorial hallucinogens and you may well become one of us . . . one of us . . . one of us one of . . .

GREG TATE is a writer, musician, and cultural provocateur who lives in Harlem. His books include *Flyboy In the Buttermilk*, *Midnight Lightning: Jimi Hendrix and The Black Experience* (which includes poems by Krista Franklin) and *Flyboy 2: The Greg Tate Reader*. Since 1999 Tate has led the conducted improv ensemble Burnt Sugar: The Arkestra Chamber, who have produced sixteen albums on their own AvantGroidd imprint.

A DIAMOND MOST SUITABLE
The Visual and Written Practices of Krista Franklin
Cauleen Smith

Come, come, come, come, come, come . . . "Invocation Wünderbar" announces the placefullness and stuff-of-this of Krista Franklin's oeuvre, inside-spaces, and exorcised rages. Franklin moves through the marvelous world armed with devastating empathy and a freshly-bladed X-acto knife dipped in orange blossom oil, dipped in mace, dipped in pig's blood, dipped in Atlantic salt water.

Too Much Midnight uses collages and cyanotypes as an architecture for Franklin's poems that punctuate, anchor, and consistently resist illustration . . . and they got me to thinking . . .

COLLAGE. "DIAMONDS ARE FOREVER"
Blue rose and blue peony wallpaper; The numbers twelves, twenty-seven, and five black diamonds; Ms. Simone fully in tact but evacuated from the scene that seems to have been vesing her, Words hover: *undersleeve, petit paquet, keep lovely, thank you*; lines for cutting, lines for sewing; stains, tears, wrinkles, and layers; a gesture; photograph; a text:

> Most diamonds are not good enough to be used for jewelry. They may be used to cut rock, glass, steel, and other diamonds. . .

This paragraph hovers over Ms. Simone. She bats it aside, tosses it over her shoulder . . . (not) good enough. Adornment signifies status. Adornment makes visible the depth and care that one takes in presenting and valuing themselves. Adornment makes one visible. A seven-pound gold chain around the neck lets us know they sling hard and smart. A Jimmy Choo in the same shade of lavender as her cashmere dress lets us know she didn't have to take the bus today. A teardrop tattoo at the corner of the eye, a pierced septum, a giant diamond on the third digit of the left hand, rainbow-colored box braids—we demonstrate our worthiness in the social order. Women are still considered a means through which men might adorn themselves. The condition of adorning makes a thing or a being so precious as to restrict its utility. Some women voluntarily aspire to this condition. And yet, I know of no woman who has had the occupation of consistently having to appear sparkling, delicious, and desirable be the only demands on her body and mind. Nope. Those who are adornments must drill rock while igniting desire.

Franklin, as luminous as she is, is a cutter. Certainly, when I read her finely chopped phrases, translucently sliced metaphors, and hot-diced alliterations, I am reminded by the ways the visual art tosses a hot flaming ball of cosmological Black woman consciousness over to poetry and then back again. Perhaps it is more accurate to call her writing and the collaging a single practice, but artists like Franklin find themselves having to invent new ways and means, new genres and disciplines to contain the nature of their production, or simply to contain their natures.

§

Paper bullets, pink gouache, come, *gold leaf, jars of water*, come. Krista is a witch. Definitely dangerous, definitely up to no good. She'll cut you. Her poems make you bleed.

CYANOTYPE ON HANDMADE PAPER. "TAPE ROCK":
I LET MY TAPE ROCK
TIL MY TAPE POPPED

Hand-made paper. Light permeates a cassette tape, its exploded guts left as intact as possible: magnetic tape storing beloved sounds just a few inches from the shell that once protected it. Brushmarks loaded with equal parts ferric ammonium citrate and potassium ferricyanide frame the light-shadows, stemming the loss, demarcating the territory of memory, time, light, and magic.

In 1842 a man figures out how to make copies of his diagrams—we know this process today as the blueprint. The world of rich British white folk being rather small, I suppose, a family friend, Miss Anna Atkins—botanist, uses the technique a year later to produce images of her seaweed collection. She is also the first person to ever publish a book of both text and photography. White silhouettes of multicellular marine algae pop off of a deep blue background. Miss Atkins created a record of things not so easy to see even though they are among the most ubiquitous plant life on earth. A cyanotype will fade in sunlight, but can be revived with exposure to oxygen. Franklin's cyanotypes of technologies like Afro picks, cowrie shells, cassette tapes, feathers, and barrettes are eternally activated and reanimated through this form.

The Prussian blue of the cyanotype becomes other kinds of blues. Can we just sit with the blue for a moment? For many moments?

> He goes back to county blue.
> But this time when he leaves,
> he's clutching a thesaurus in his hand
> like a shank.
> —from "It Do What it Do
> (Me & Homer Talk Poetry)"

Can we imagine a future in which Homer emerges from the county blue holding a trident-shaped thesaurus inside his mind as he tries to find someplace to write before it's time to go looking for work? Franklin creates a space between her words and her collages that suggests possible futures and draws balms and tinctures from obscured pasts.

§

COLLAGE ON PAPER "WE WEAR THE MAST, II"

A head of sea coral, but she see; a flock of eyeballs doing reconnaissance; curves of a juicy caramel body wrapped in a rust and yellow marigold patterned textile—now armed and released from performing adornment; a steel pipe that, she being a diamond, only she and her kind can cut; left hand a fan of toxic coral. She cut you. She makes you bleed; She no mermaid—tentacles propel her vertically across the rag paper—she Cthulu—she beautiful terrible monster—she free.

§

Come sit with me and *Too Much Midnight* under the "most beautiful Sycamore evah," and think about the way Franklin insists upon leaving Black bodies intact when she cuts them out of the image in which they were captured to bring them into the marvelous Black nostalgic future past of her collages. Of course, augmentation is necessary. I mean, we are an augmented people, are we not? Our ancestors were packed onto a ship as peoples and survived on alien shores as (an)other thing(s) altogether. Adaptations and augmentations were necessary to become the thing that we now are—that Krista sees and feels and knows and loves. In a Franklin collage, Black bodies may be augmented but never mutilated. More frequently she might crack open the skull pan so that we might better see the inchoate thoughts of an adolescent girl or imagine hearing the music that cocoons a walk down the street or on a bus ride. (White bodies fair less well: hands hold the strings, heads are muzzled in industrial appliances that were supposed to be the homemaker's best friend.) The collage is a portal that demonstrates the rigorous way that Krista collates history, images, language, experience, and memory into a galaxy pulled toward its black hole with all the toil and tempest we can muster.

Not only am I intact after reading *Too Much Midnight*, I am—while weeping for Homer, and worrying for other people's kids, and walking home at night clutching mace (or a blade)—whole.

CAULEEN SMITH is an interdisciplinary artist based in Los Angeles, California. Smith enjoys container gardening, likes cats and collects vinyl records, rocks, and books. She is an avid leisure and functional cyclist. She is art program faculty at the California Institute of the Arts. She holds a BA in creative arts from San Francisco State University and an MFA from the University of California, Los Angeles School of Theater Film and Television.

TOO MUCH MIDNIGHT

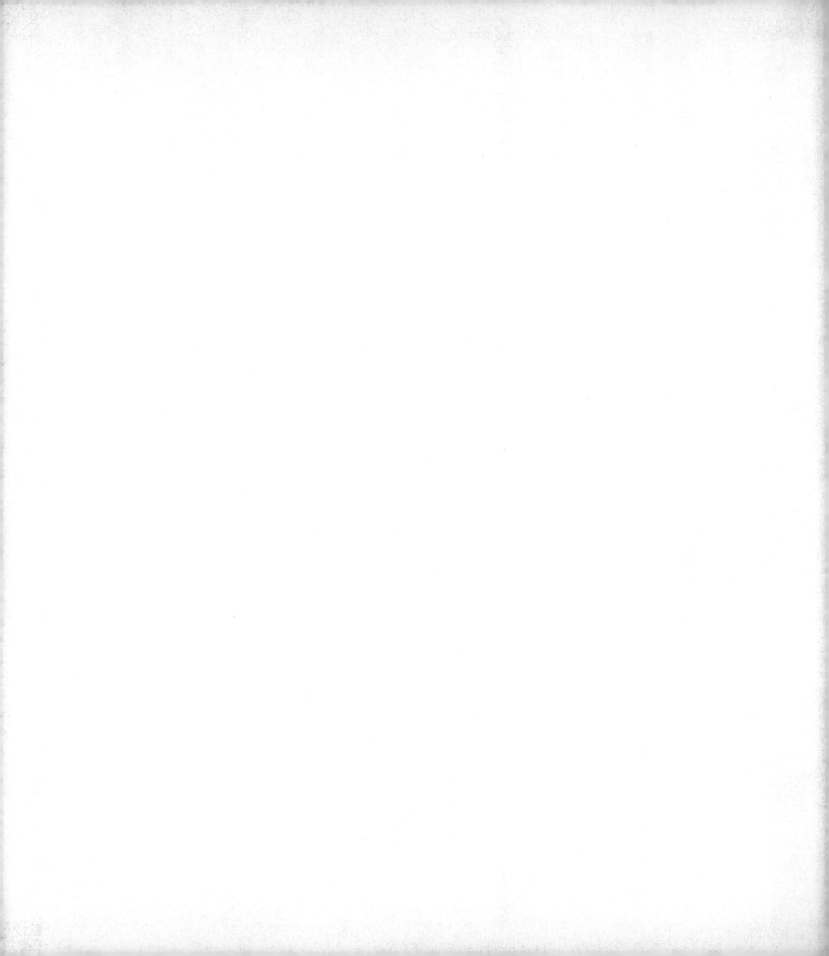

KILLING FLOOR

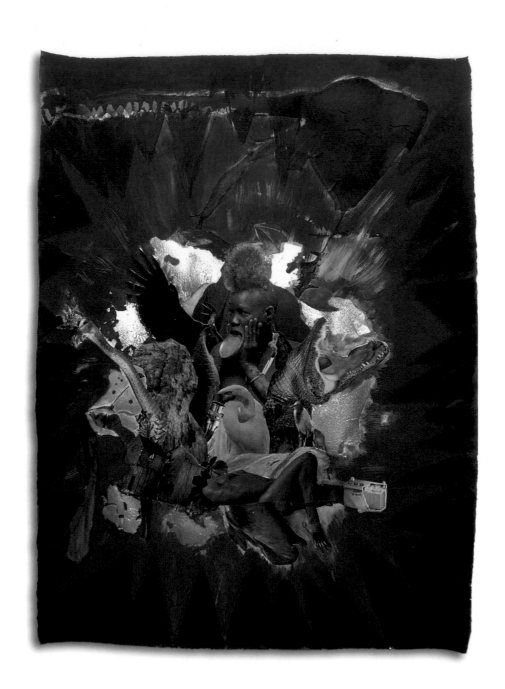

MANIFESTO, OR ARS POETICA #2

Give me the night, you beasts hissing over the face of this dead woman, I climb into your eyes, looking. To those who would sleep through the wounds they inflict on others, I offer pain to help them awaken, Ju-Ju, Tom-Toms & the magic of a talking burning bush. I am the queen of sleight of hand wandering the forest of motives, armed with horoscopes, cosmic encounters & an x-acto knife. My right eye is a projector flickering Hottentot & Huey Newton, my left eye is prism of *Wild Style*, gold grills, lowriders, black dahlias, blunts & back alleys. At twenty-one, I stood at the crossroad of Hell & Here, evil peering at me behind a blue-red eye. I armed myself with the memories of Pentecostal tent revivals, apple orchards, the strawberry fields I roamed with my mother & aunt in the summer & the sightings of UFO lights blinking in the black of an Ohio nightsky. I am a weapon. I believe in hoodoo, voodoo, root workers, *Dead Presidents*, *Black Tail*, *Black Inches* & *Banjees*. I believe in the ghosts of sixty million or more & Black bones disintegrating at the bottom of the Atlantic, below sea level, *Not Just Knee Deep*. *I believe that children are the future*: love them now or meet them at dusk at your doorstep, a 9mm in their right hand & a head noisy as a hornet's nest later. Your choice.

Black, still, in the hour of chaos, I believe in *Royal Crown*, *Afro-Sheen*, *Vaseline*, *Jergens*, & baby powder on breasts, the collective conscious, cellular memory, Public Enemies, outlaws, Outkast, elevations, *Elevators* & *Encyclopedia Britannica*. Under my knife, El Hajj Malik El Shabazz laughs with Muhammad Ali, a Lady named Day cuddles with a Boxer named Mister after traumatically stumbling on strange fruit dangling from one of the most beautiful sycamores evah. Under my knife, Marilyn Monroe enjoys an evening out with Ella Fitzgerald, meanwhile, *Life* shows me a gigantic photo. I am a weapon. I chart voyages of unlove, high on a man called crazy who turns *nigger* into prince. I believe in Jong, Clifton, *Dirty Diana* & Dilla, paper, scrilla, green, gumbo, coins, Batty Bois & Video Vixens. I believe that beads at the ends of braids are percussive instruments in double-dutch. In the reflection of my knife, Cab Calloway, Duke Ellington & Thelonius Monk argue in a Basquiat heroin nod. I am a weapon. I believe in goo-gobs of deep brown apple-butter, alphabets, Alaga syrup, Affrilachians, A-salaam Alaikum, Wa-Alaikum A-Salaam & African Hebrew Israelites. I believe in Octoroons, Quadroons, Culluds, *Coolie High*, Commodores, Krumpin, Krunk & *Burn, Hollywood, Burn*.

I am Sethe crawling a field toward freedom with a whitegirl talking about velvet. I believe in tumbleweaves, hot combs & hair lyes, Shaka Zulu, Mau-Mau, Slum Village & *Buhloone Mindstate*: *Empty your mind. Be formless, shapeless—like water. . .* I believe in water. My body is pulp. I bleed ink. I believe in the *Fantastic (Vol. 2)*, *Low End Theory*, *Space Is the Place* & *The Hissing of Summer Lawns*. Tucked in the corner of my right ventricle sprouts a Tree of Knowledge, lives a Shining Serpent & a middle finger. I'm on a quest for the Marvelous. My face is a mask of malehood, malevolence, one big masquerade. Metaphysically niggerish, I am a weapon wandering the forest of motives, a machete in one hand, a mirror in the other, searching for the nearest body of water.

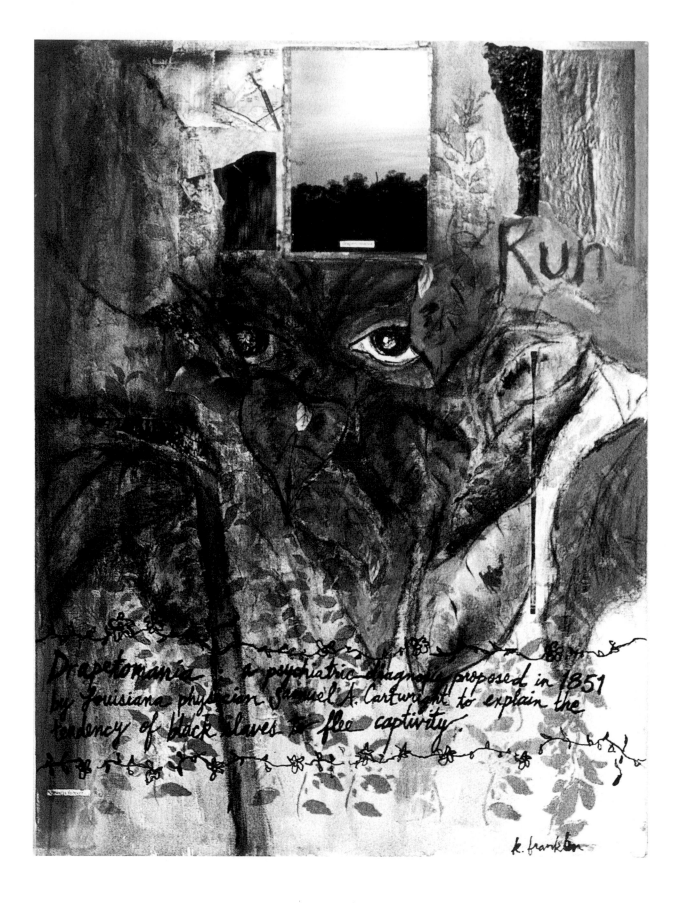

Run

Drapetomania, a psychiatric diagnosis proposed in 1851 by Louisiana physician Samuel A. Cartwright to explain the tendency of black slaves to flee captivity.

k. franklin

DRONE: ECOLOGY

Wanna bumble with the Bee, huuh? BZZZZT!
 —Lil Kim

There is a homecoming
queen perched on the throne of our aortas,
her blood pumps the throb
of a thousand wings
buzzing her bidding.

We like babies, eyes turned up
in the dazzle of the collision
of metal and light, the artful waltz
of shine and shadow, our
imaginations at the knifepoint
of allurement.

There is a swarm of women's ears
budding in the piping of G#,
their fingertips a score of hashtags,
a shellacked clatter of acrylic
poised in the alphabet
of attack. Their keyboards
dance a pattern in service
of empire, a blinded colony
of complicity.

Does a drone know
he's without sting? His body
a circuitry of servitude designed
by his mother, his life forever
tethered to her will?

And what of will? Are we in thrall
to the shimmer, the circuits, the circus
of our mouths salivating
the seat of power? Our eyes
like toddlers in the dazzle
of life's pileup, our appetites
hardwired for war.

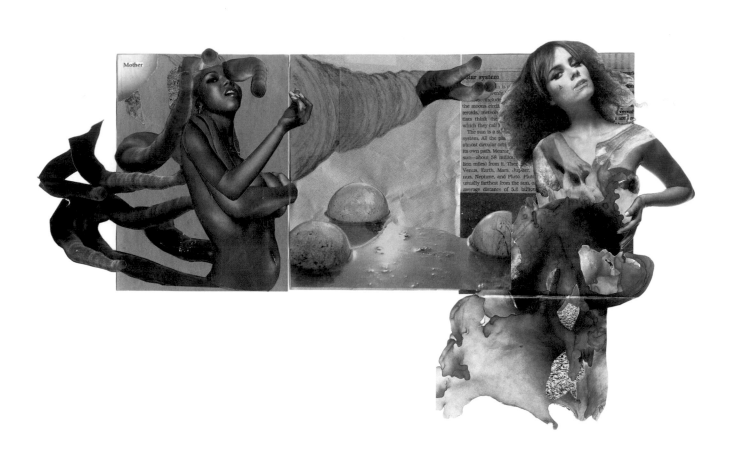

IT'S THE SKIN THAT TELLS

i.

It's the skin that tells the tale.
The tone, marred by chromosomes
of beasts, brothers. The sign of something
insidious risen up in flesh. Black women's
thighs pale as the men who fathered them;
some animal who's smile can still be
seen with a body burning as backdrop.
The cross-stitch of power and powerless
erupting into redbone, the swarthy
surprise of Aryans.

ii.

The sight of angels will turn your eyes
to ash. Once I saw the mark of Auschwitz
inscribed on the arm of one of the sweetest
men I've ever met. For years I wore the coat
he walked out of hell with, the ashes of his
family stuck to the roof of his mouth. He turned
it over to my teenaged hands for me to carry.
His memories. My upper arm now inked;
I can never forget.

iii.

The brightest angel of all was wrestled right
out of Heaven. One evening, I sat face-to-face across
from a boy whose body was a suitcase
that held a minion it. I will never forget his gaze,
how I wanted to turn from it, and the reality
that sometimes we are pushed from the shells of ourselves,
how flesh can be Geppettoed if one isn't careful.

iv.

There are many ways to be a slave. To be beasted, beastly,
beast. Many ways to be monster, monstrous, insidious,
insidioused, Auschwitzed. To be dragged, drugged,
worn like a coat, weary. Many ways to be marked, marred,
wrestled, wrecked. And it's always the flesh that sings,
signs, squeals.

AFTER RASHID JOHNSON'S "SELF-PORTRAIT LAYING ON JACK JOHNSON'S GRAVE, 2006"

I lie on the backs of ancestors

Wife white
socialites & old money

When I open my mouth
you wouldn't believe the shine

Gold & Grills
are double entendres

The only times I shuffle
in the ring & poker table

I give good face

My women are full-length minx
I mean, minks

Blackness is unforgivable
I ivory tower unforgettable

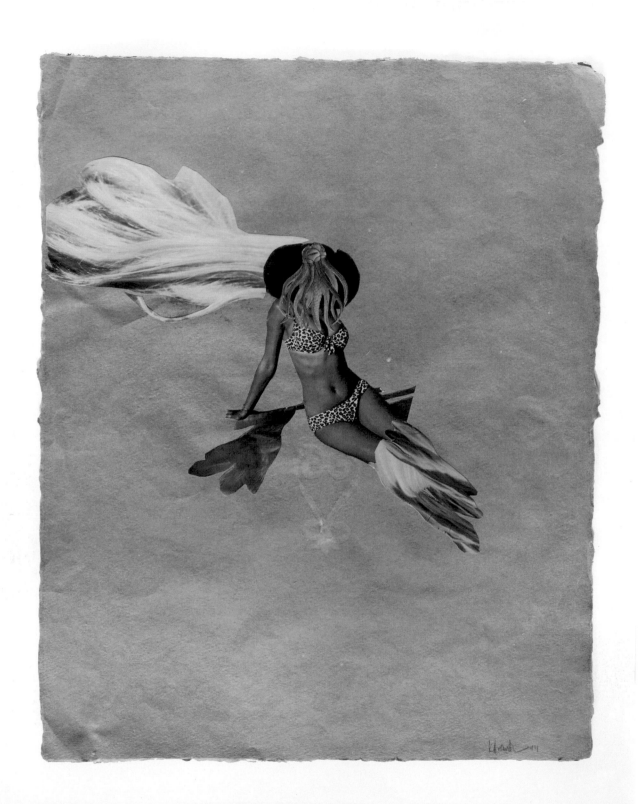

SATURDAY NIGHTS AT THE BUG INN, 1986

Plastic cups watch from the divide between
pool room and dance floor. Their golden insides
pulling stingy light down from the ceiling.

Drunk men, eyes hard as wood floors, watch.
Some lean their bodies across pool tables,
one pale arm stretches down the length of stick.

There is no space on the small dance floor.
The smattering of brown bodies here squeeze
into any open space they will.
The bar air, swells with sweat and sound,
my mouth fills with my phone number.

The deejay spins almost every word we know:
Ratt, AC/DC, Def Leppard.
Electric guitars climb out of speakers,
and slither into our hips. We are four black virgins
perspiring in the heat of roadhouse.

My voice is caught in the grooves of night.

Like big cats in a forest of antelope,
the few Black boys here circle white girls
who sprout from these backroads, smell
of hairspray and floral alcohol of drugstore perfume.

I am here for anyone and no one;
sit in a dark corner with my legs stretched on another,
drink water and watch the ritual of torsos
pressing against one another, the mysterious
conversations falling into caverns of ears.
Here, I perfect my *I-couldn't-give-a-fuck-less* face.
Glare at the ones who stare too long.

Inside, I am howling wolf.

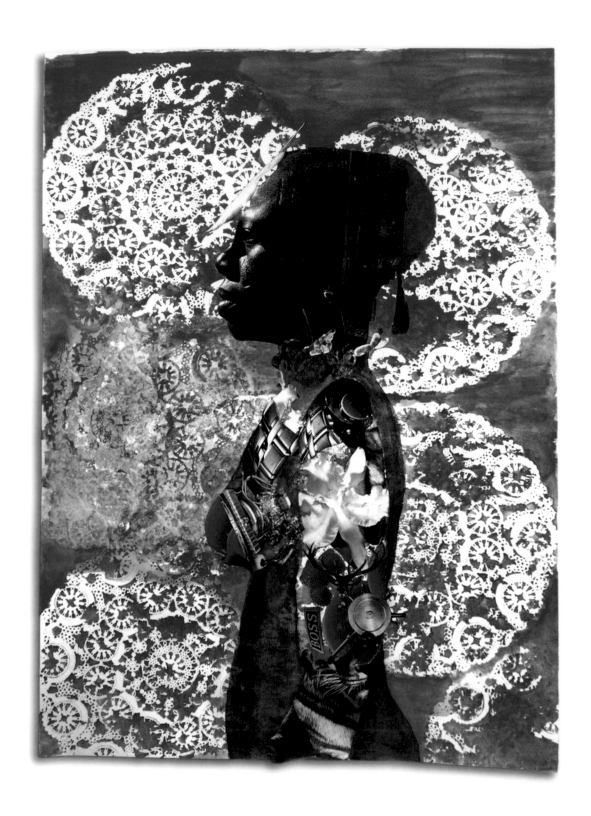

PREFACE TO A TWENTY-VOLUME HOMICIDE NOTE: FOR AMIRI BARAKA

Today, I turned *Transbluesency* over
to the hands of a teenager tussling
with her own words, still trying to decipher
the difference between invention and insipidness.
Meanwhile, you know, the world whips against
our hunched shoulders and McKay's call to arms
is buried in the graveyards of the poets' imaginings,
its ghost inhabiting some young soul in Egypt,
rumbling in the heart of Libya. Meanwhile,
America picks the lint from its navel, moonwalks
its way back to antebellum inertia, lulls itself
to sleep with airwave regurgitations of the 1970s
before the music sold its soul for a stripper pole.

At your lecture, we sat in the Amen Corner
and hallelujahed your every word, knowing
over half that room didn't know Tyner from
Tyson, couldn't pick Monk out from a mugshot.
Meanwhile, while knee-grows still swallowing
the jizz of the American Dream and south-
side Chicago teens juke Africa in hyperspeed,
we still ain't caught up where we need to be,
more concerned with how much gold we can
dig out a broken nigga's pocket, debating the political
incorrectness of the word *bitch*, and which came
first: the pimp smack or the egging. Baldwin broke
himself writing tomes on Black love while chain-
smoking and dragging racism out to the streets
by the scruff of its dirty neck, all to be reduced
to "the gay dude?" in the college classroom.

Who's gonna save us now that all the Black heroes
are running from the cops holding their pants
up with dusty fingers they never deigned
to open a book with? Black heroes more concerned
with erasing their records and record deals

than delving into solving the algebra of Black agony,
bolt-cutting the inextricable chains of imperialism
that got everybody tied up in knots. Who's gonna
save us now that all the Black heroes are making
it rain in sweatshops where the heroines calculate
payouts in booty-bounce and the drum
got pawned for a machine?

THE TAR BABY SPEAKS

obsidian shine
bright as moonbeam
smoking cool
hot flesh, soft
as wet clay

just gone sit a spell
(work a root)
take in all the wild-
life. Ants, junebugs, grass-
hoppers *(hippity-hop)*
flies stuck on my shoulder

cute as a sun-
hat cocked
like a Colt, smoking
enough to peel a cap
back. Bunny-rat,
rabbit, reckless eye-
ballin' shady
as an old oak tree

> *(think I don't see?)*

me, Venus fly,
roadside romance.
sneaky, he sidle-up.

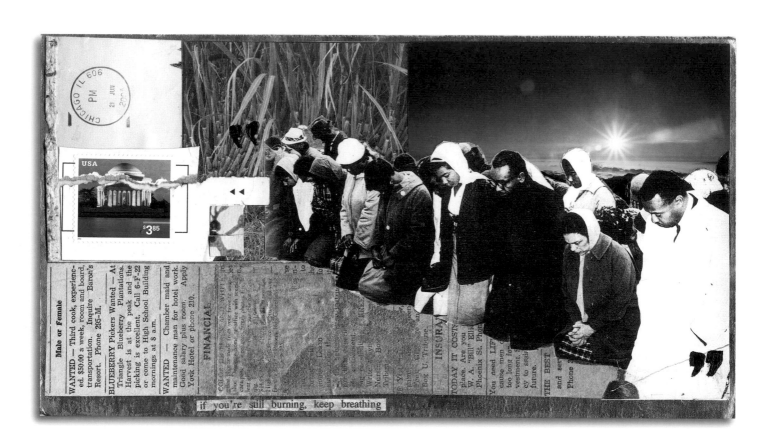

CHICAGO IL 606
PM
21 JUN
2004

USA
$3.85

Male or Female

WANTED — Third cook, experienc-
ed. $50.00 a week, room and board,
transportation. Inquire Baron's
Resort. Phone 295-M.

BLUEBERRY Pickers Wanted — At
Triangle Blueberry Plantations.
Harvest is at the peak and the
picking is excellent. Call 6-F-22
or come to High School Building
mornings at 8 a.m.

WANTED — Chamber maid and
maintenance man for hotel work.
Good salary plus room. Apply
York Hotel or Phone 210.

FINANCIAL

INSURAN

TODAY IT COST

You need LIF

THE BEST

if you're still burning, keep breathing

KILLING FLOOR

There are women who love the taste of their own blood.
Most will never say this. Or do in hushed voices,
whispers that scurry over swept floors like rodents in the dark.
We catch glimpses of them from elevator cameras
placed way up high where no one can reach them
nor have the good sense to smash them out.
Most of us bash car windows or the cheeks of men
Who love us. Or claim to. Cameras are too much trouble.
Trouble walks on two feet with eyes that blaze like a shot pistol
& it's often confused for desire. Or maybe it is desire
for broken flesh and mashed mouths. For the wetness
of tears brushed away by thumbs in the aftermath.
Who knows. The unknown is alluring anyway.
Identity is incidental. It's better not to know
When you have an appetite for crimson, raised voices
& wrestling that masquerades as sex. How many women
smack the faces of their rescuers? Scream into the fullness
of help? No one likes to mention this. It shatters
like the mirror against the fist of a beloved. Cracks
like a tooth after too much midnight.

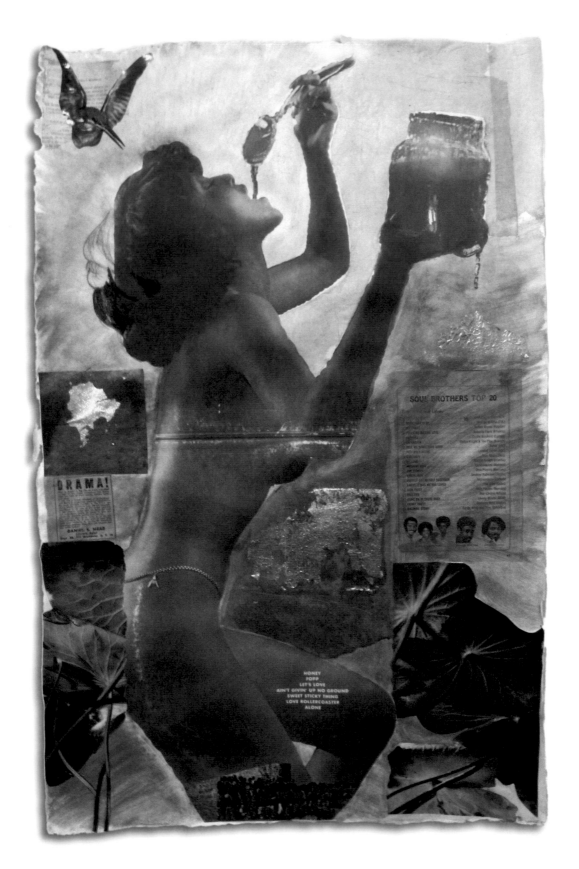

DEFINITION OF FUNK

FUNK, as in *pee-eew!*, as in *stank*, as in *doo-doo*, as in *ooooo weeeeee!*, as in a good thing gone *baaaad* in the dark corner of one cold location like a Frigidaire or a once-flooded moldy basement. *FUNK*, as in "a foul odor," as in "a dejected mood," as in "cowering fear," as in pheromones dispersed from a running body through dark woods tracked by bloodhounds, as in *We's free??*, and a pungent confusion of *that* ominous realization, as in the cellular memory of the scent of the wet wood of an auction block, or the smelly sound of a mother moaning in a dank cabin, her babies hauled off in a rickety wagon.

FUNK, as in "a style of R&B music," as in a bass line that travels from point A to point B, "A" as in antebellum or Africa to "B" as in Black or Brown, *James*. Or a bass line that travels from point A to point B, "A" as in abolitionist or Abernathy, *Ralph David*, to "B" as in Blaxploitation or Baraka, *Amiri* or Bootsy (Collins). *FUNK*, as in *Make my FUNK the P-FUNK. I wants to get FUNKED up*, as in *I don't know, but whatsomeva it is it gots to be FUNKy!* FUNK, as in 1970s Ohio, as in British Rod Temperton walking off Wright-Patt Air Force Base right into Dayton's west side, as in a grown man named Sugarfoot, as in a pot of chittlins bubbling on some Black woman's stovetop, or a saxophone in the mouth of a man named Maceo.

FUNK, as in electrified organ, as in Edison meets Hammond, as in pounding pigskin, as in foot-stomp on the wet wood of an elevated platform, as in *platforms*, as in stank swamp water, black lagoon backwash, Dandelion moonshine distilled in the backyard of some Black woman's bungalow, as in syncopated sass-mouth high on the voltage of freedom & an audacious idea of owning yourself, *FUNK*, as in crawling up out the pit of hell with shattered pants smelling like fire & brimstone, as in Black boys' fingers strumming the silky red hem of a Siren, as in hi-hats & old women's warnings that a body that refuses to be owned often ends up at the dangling end of a rope in the most beautiful Sycamore evah, as in the smelly sizzle of hot combs & hair grease, as in crossroads between Hell & Here, or between Kentucky & Ohio, as in *Ju-Ju*, root worker dust that flowers in the dark hearts of men who run amuck, women who press their luck.

BLACK BULLETS
After Jeannette Ehler's film Black Bullets *& For* Black Radical Imagination

Saint-Domingue was the first Latin American country to, in 1804, gain independence as a result of the only successful revolt by enslaved Africans in history. The rebellion began with the legendary Voudou ceremony at Bois Caïman in the northern part of Saint-Domingue. A black pig materialized and was sacrificed in a ritual during which hundreds of enslaved Africans drank the pig's blood. The blood gave them power to fight for freedom."
 —**From Jeannette Ehler's artist statement about** *Black Bullets*

It looks like a demon; that's how angry he looked.
 —**Former Police Officer Darren Wilson,**
 in his statement about the shooting of unarmed teenager Mike Brown

Sixty million spirits caterwaul from a grieving mother's mouth.
Her tongue is a bullet that ricochets her heart's tender meat
into savage fraction. When your body is the architect of a boy
you are called to identify—his bloodspill careless
as orange pop on a sidewalk—you are a dry, black well, a language less
hollow, a howling that calls the wolves to the bloodletting.
No longer a mother. The day you brought the infant home
is a swallow in the red raw throat of time, your life an accident,
an incident broadcasted by the blinking shutters of one thousand
lenses. You are blind and boxed in. The boy you once walked
through the door of a kindergarten classroom is reduced
to executioner's excuse, a tattered canvas of white anxiety.
He is not a boy whose snotty nose you wiped at night, delirious
from no sleep, your last $20 just sent out the door for cough medicine.
He is an anthology of myths spinning from history's filthy mind.
He is cannon fodder, smoking gun, two hundred years of angry niggers
creeping up the Big House steps. He is not the sheepish boy suppressing
a smile with the name of his first crush on his tongue. He *is* a crushed
tongue, anonymous police diagram of entry and exit points.
The dandelion he handpicked and handed to you at four is withered
and blown into slogans crudely drawn on poster board and held up
for the world to see. When all the Black Death sucks the air from your lungs,
it dawns on you: the sky is a menace, a succubus dragging everything
you love upward into bloody Rorschach, a chem trail constellation of tear gas canisters

blossoming into cloud. And all that's audible is electric low hum
and drum. The tension-pregnant veil between This world and That
frays at the seams. What only the sorcerers see is Invisible marching right through.
It's in the ether, steaming from the bodies' last breaths, stuttering from the mouths
of mothers whose phones ring with coroner's calls, the lies stacked up like corpses
in a pit, the colonized bellyful and safe in their mirage, their lips greasy
with excuses. We all want to live. Even the mothers who are hollow as bullet points
that exited the same back of the scalp their palms caressed. This is not a war
of the flesh. But of the spirit(s). Who, even now, are marching toward us,
sinking through the quicksand of flesh and contaminated sky, their maroon
hands glistening our weary bones, our fullness on their fingertips.

EXTRAPOLATING MOTHERHOOD

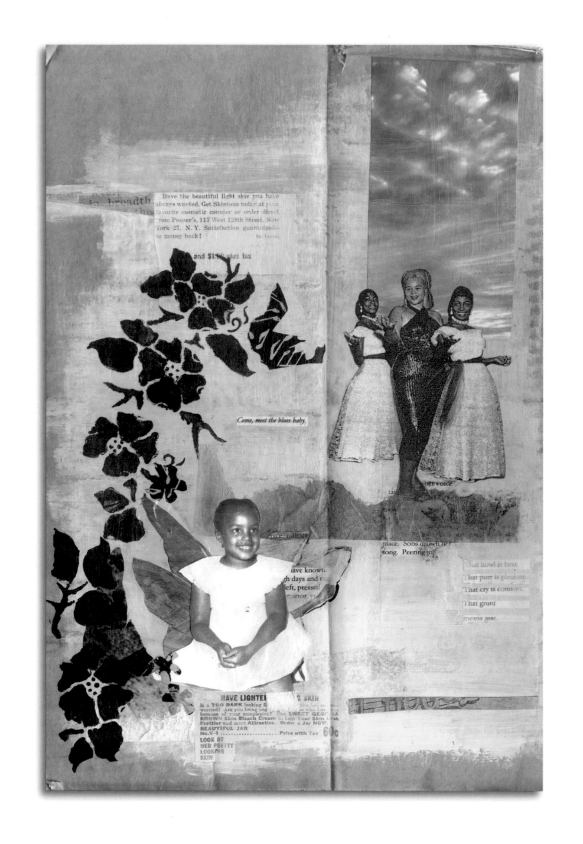

EXTRAPOLATING MOTHERHOOD

Outside, at two in the morning
I say "motherfucker" for the Colombians
to teach them how to cuss the way only
an American can. *Drop the "R"*, I tell
these men who roll R's as pretty as some
of my friends roll joints. We are five different kinds
of drunk, high off the promise of summer
and a white, pregnant moon. I think of Paulette,
years ago at the Christmas Party, newly
pregnant with a boy named Gabriel,
pissed off at everything she could not
have: the bottle of vodka the Russian broke out,
the stinky mushrooms sneakily circulating.
This is the story Gabriel will never know;
the first night he stood in the doorway
of his mother's true nature. How she departed
abruptly to grapple with his arrival. How many
women never speak of this.

A DJ leans in my passenger's side window
to spin a yarn bout Babymama Number One,
how she'd show up at his gigs swoll up with
the best track he'll ever lay or play, and perch
up on top the speakers. This was supposed
to tip me about how wild she was. Forgive my
vulgarity: when a woman pushes a person
out her pussy, it transforms her. This is what
I'm telling you. It's not always good.
When I was just a girl, my mother made this clear,
feeding every child in the neighborhood,
dragging every unwanted kid off the street.
There are so many children, but mothers
are scarce. Or scarcely sane, plowing their
seed with every insecurity they dream up. There
are multiple narratives to every story. Why not
those of mothers?

I marvel. These women who defrag to DNA,
expand like magic, quell wails with their breasts.
I don't begrudge that. Nor the exquisiteness
of a six-month-old cheek, the charisma of a toothless
grin. Being a kid is more appealing
than having one. Only a woman no one calls
"Mama" should stand outside at two in the morning
teaching how to say "motherfucker."
These are vulgarities one should not
reproduce. Some folks don't get that,
and have kids anyway. It's one of the reasons
my mother fed them. There are times
those children and I lock eyes. Being a child
like them, I cannot tell you what they tell me.

COMMITMENT

She determines not to roam;

in a temple
she dreams *Desire*,
her only child.

From a cedar pew,
she beckons his head
wild with uncombed hair.

(Wanderer, he roams
avenues of her mind.)

She rises
when he comes,
takes his hand,
leads him to the altar
where the smell of myrrh
swells like a punched eye.

Stay,

(the bowed strings
of Chaka's voice:
the soul breathed into longing).

With moist palms,
she helps him up,
lays his prepubescent
body on the table.
Her right arm raised,

she waits,

something sharp in her hand.

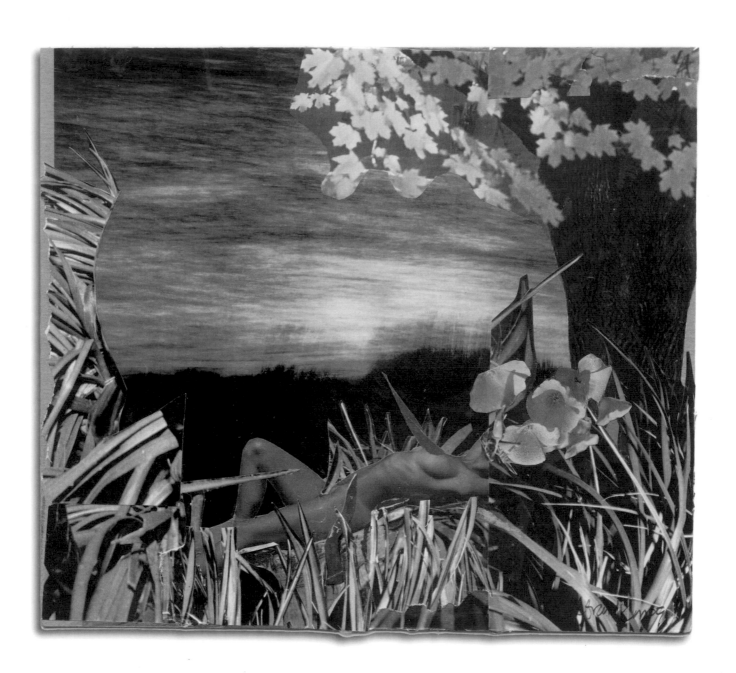

BELLY

Inside the crumbling black
of the body, hell rumbles
hisses like the rear end
of a rattlesnake, right
before it goes off.

The liquid mess of it—
hell—all heat and fury,
bubbling like snot
on the face of a crying
three-year-old, poised
for explosion.

And it looks like God
threw a hand grenade,
golden and crimson,
pushed into air traffic
with one violent shove,
vomited into sky's
blank stare, spilling
out onto surface
of beleaguered stones
yielding a winding stream
afterbirth of fire.

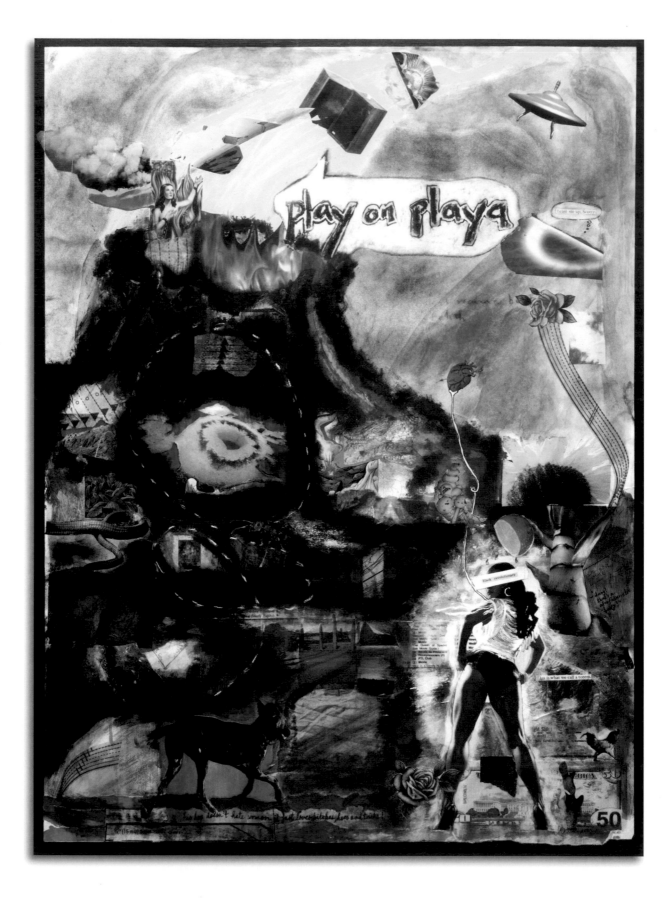

FIFTY PERCENT OF WOMEN HAVE THEM

In lieu of a baby
my uterus decides to grow
tumors instead. Fibers,
like tiny tentacles, winding
around one another like
the strands of DNA
they wished they were;
winding themselves
like a tourniquet,
or a tight ball of yarn inside me.

When my gynecologist presses
her cool fingertips to my abdomen,
she says: *I'm going to have to do
surgery.* And with one index finger
hanging in the air like an
exclamation point, she draws the line
where she'll cut me open
like a cardboard box.

Later I tell a friend:
I want to see it when she's done.
And imagine the formaldehyde-heavy
specimen of all my tiny
obsessions, thin
blue fears intertwined
like copulating lovers.

All my worries
grown like zygotes,
solid, benign
but for the beat
of my pulse.
The stillborn mass
of my inner Medea.

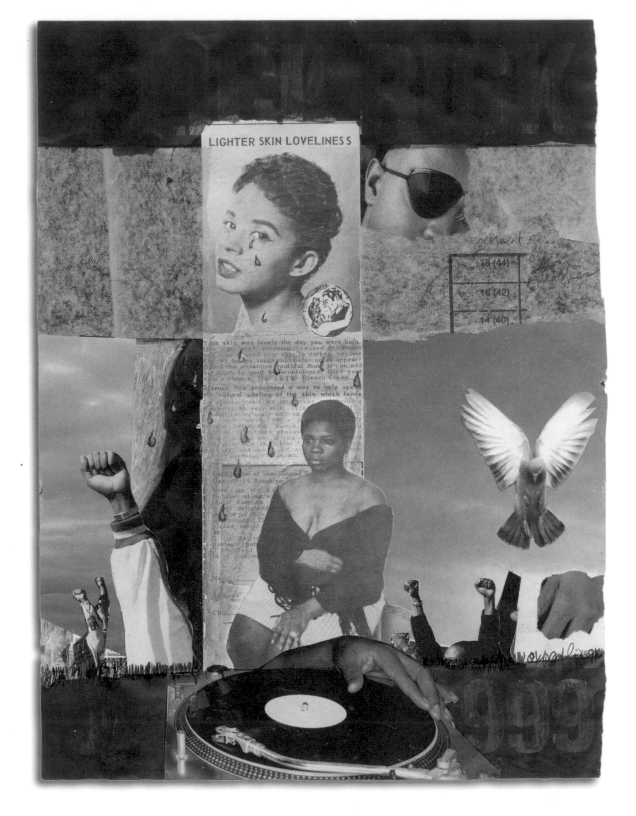

PROBE

i. *The Office*

Naked, back
against the backless
gown, and rolling reams
of paper that rip
clean after departure.
Skin pulled tight,
zippered flesh, a coat
size too small.

ii. *The Observation*

Latex is a language
of orifices and appendages,
snapping tongue of the biohazard,
a probing way of touching, without.
Doctors and lovers both
speak it, safe
inside its sterility,
reaching themselves
in the closet of you,
the places you house
the most intimate.

iii. *The Diagnosis*

Don't get excited.
Skin is a thin coat
worn to wreckage,
scars, the openings
and closings of invasions,
and former sites of penetrations
gone awry, the fraying
at the seams of things.
Plastic can't protect us
from that: our selves' erosions,
and exposures to dangerous insides.

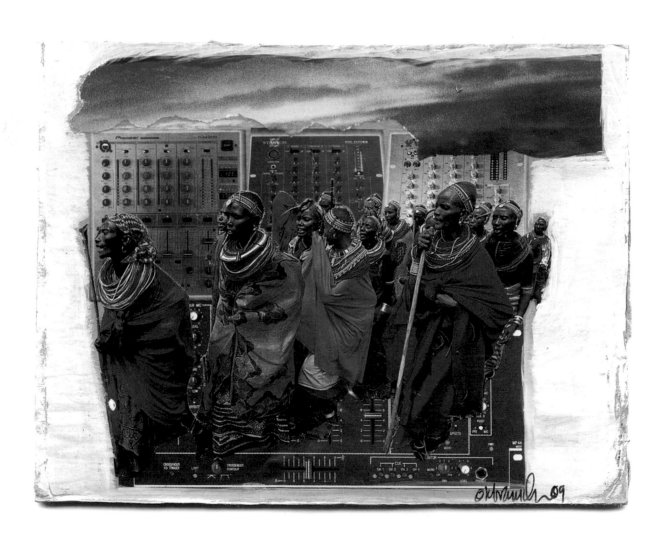

LUCIDITY
(ars poetica #1)

"Let's close her up,"
 says surgeon, Dr.
No Name, masked under
 lights, white,
hands wet
with blood, rich
and worrisome.

Listen as the belly bubbles in
its new arrangement; organs
elbow each other like professionals
 in a crowded elevator.
Try to create space and flow
 in an atmosphere of darkness,
 (and) invasive procedures.

 *

The blood on his hands is mine.
The organs, mine, all
named though I only know a couple,
and never their rightful place
 like my mother, who never just breaks
bones, but fibulas, tibias,
 the proper names of things
trapped in the vice of her mind.

My mind is on the surgeon's
tray, the scalpel, the bounty carved from me.

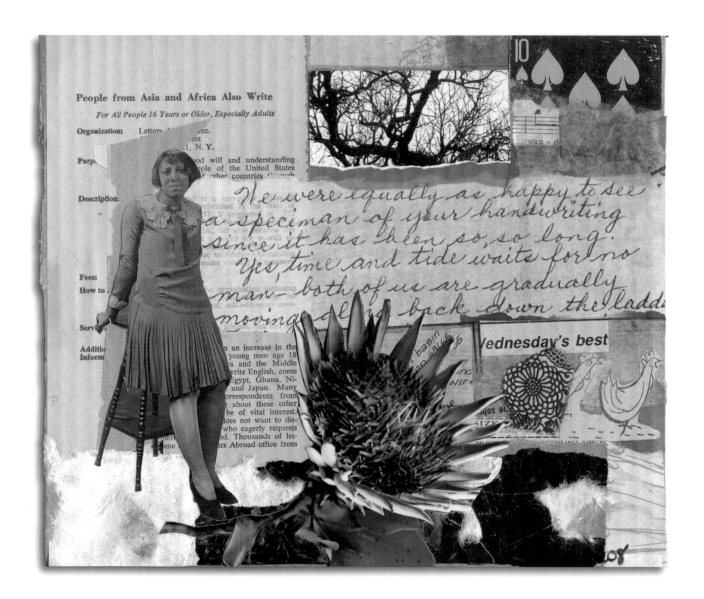

INFINITY: A LOVE POEM
for My Mother, C. F.

This is her answer to everything:
Get on your knees
Draw a beam of light
From God's eye

Get on your knees
Pull the answers
From God's eye
Gaze cast wide as fishing net

Pull the answers
Buried in the code of your body
Gaze cast wide as fishing net
There is no separateness

Buried in the code of your body
The secret to eternity
There is no separateness
Progenitor is progeny

The secret to eternity
Tucked on a shelf in her mind
Progenitor is progeny
Her womb full of others' children

Tucked on a shelf in her mind
My body passing through hers
Her womb full of others' children
She heals herself

My body passing through hers
Hazy as a 95-degree morning
She heals herself
The divine erupts inside her

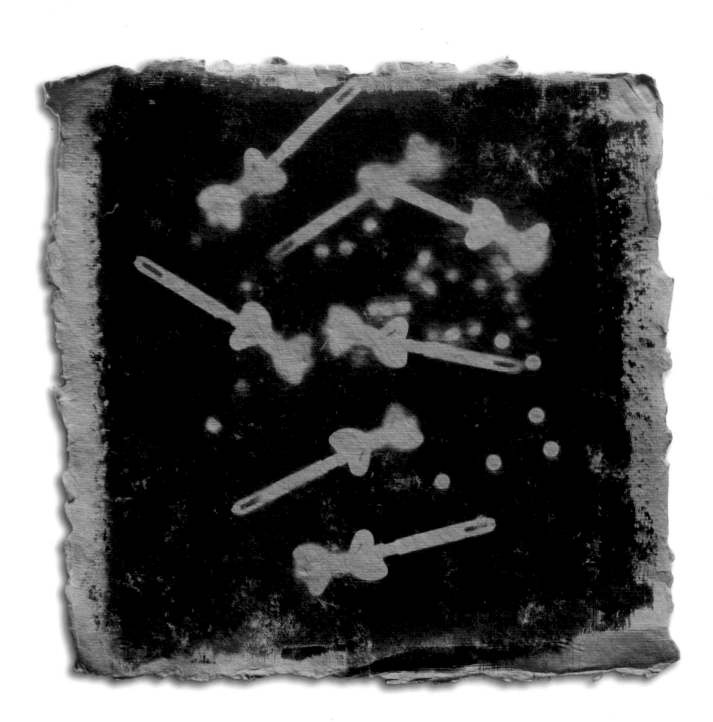

ORIGIN & ETYMOLOGY

Rumor has it, when I was only a heartbeat,
a still-forming sycophant siphoning
life from the body of my mother, my name
lived in the mouth of a woman calling
to her daughter in Germany and traveled
through the streets to rest in my aunt's
inner ear. She passed the electric secret
to the distant receiver of my mother's telephone.
The games that young girls play; they collected
K's to label all living things on two legs
(or four) that came to rest in their laps or be
fed from their tables. Kerry, Kevin, Krista, Kapri,
Kasha, then Kreighton. My name came
from a game four young girls played
while I was still forming, a parasite fetus
feasting on the bodies of my mothers. They
called me Krista and followed Christ, they
slicked my baby head with olive oil, wrapped
me in receiving blankets of Bibles, they
believed in resurrections, raptures, sin
and Second Comings. They called me Krista,
Christian, they baptized me with light.

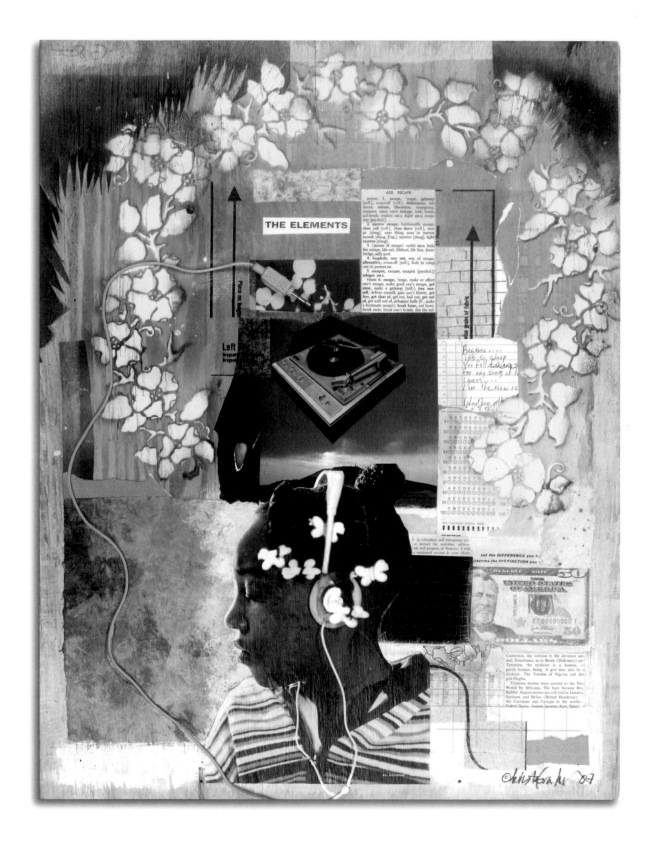

SOMEONE IN MY FAMILY

 tree was pluck-pocketed

 and bitten core clean seeded sent off far out

strange land stranger cracked between two tongues to

untangle

thrust among albino alien bent down tobacco terrain

 branded named crossbred map-

 less

 hapless (*here I am!*)

some poor sap's genetic switch witch hopped a

 hundred generations inside blkbody

 spaceships crash Lando

Calrissian traitor survivor of Hun & Hut

 extraterrestrial mutt

 saber gold tooth

ore & ire equipt: Jedi mind trick

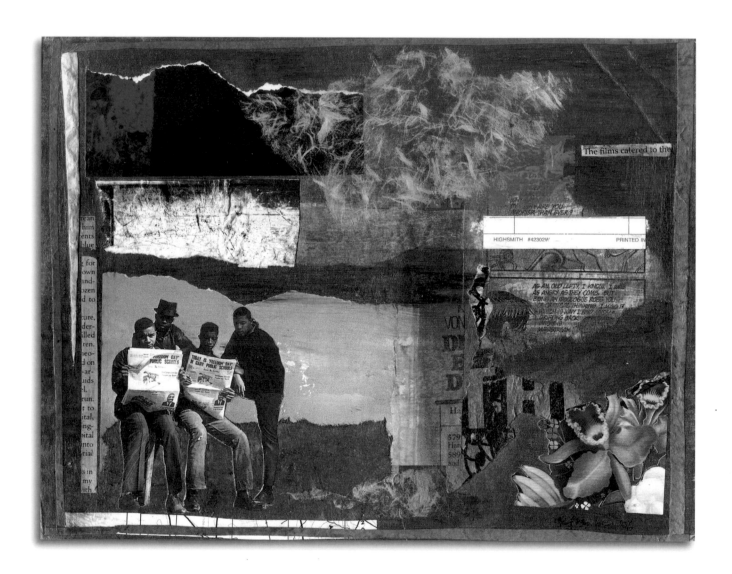

NOCTURNE

In all this blue-black everything
transforms, fallen branches scuttle
streets like rats, the moon ripples
on the face of Lake Michigan, eyes
reflect, refract like broken mirrors—
fear, desire, hunger. New lovers turn
their bodies into bonfires and stoke
the flames with their tongues. Right
now, some boy's cheek-down
on a cooling hood of a cop car
thinking home ain't so bad,
on another block a girl is fingering
pepper spray in the bottom of her
handbag smelling like booze and faded
perfume muttering come and get it
down a deserted street. Somewhere
a newborn is sleeping through all
of this, dreaming of his mother's
breast, the ghost of his grandfather
posted quiet in the nursery's corner.

ALTERNATE

There:

Sitting in the newsroom. Number two pencil between her teeth. Narrow notepad splays open next to keyboard, half-legible scribbles spill over blue lines. Suffocating on deadlines. Caffeine heart race, stomach swollen with fast food and Black tears inhaled through ears. Pecking an alphabet of bad news. _____, Black, male, 17, _____, Black, female, 19, _____, Black, male, 23, _____, Black, female, 35, _____, Black, male, 12, _____. The editor walks past the cubicle where she half-lives, says, "Good work, Franklin."

And there:

Standing at the stove. 5 a.m. One wild-haired baby girl on hip. Pointing. "Skillet," she says. "Skillwet," she says. "Egg," she says. "Eg," she says. "Da-Da," she says. *Prison*, she thinks.

And there:

Legs akimbo. Ankles in stirrups. Suspended in air. Ass at table's edge. Anesthesiologist syrup smile at shoulder. Needle in vein. Mask man surgeon stands between *V* of open thighs. Dead eyed. Mouth invisible. Anesthesiologist counting, *10-9-8-7-6-5-4-3-* mask mouths, *2*.

"Night, night."

And there:

On her knees. Doubled over. Weeping at the threshold of bedroom and suicide. Snot on tee-shirt. Infant screams from the crib. A wet letter in hand, the signature of a man America transformed into a numerical mystery.

And there:

A conch shell howling. Vacant in a white room.

And there:

Secretly sloppy drunk. Laughing at the unfunny soon-to-be conquest. Thinking, *Is he the one? Is he the one? Is he the one?*

And there:

Thick, thick, rich and *Rubenesque*. Exquisitely framed in ornate gold-leafed ebonized wood. High, floating on eight hundred-thread-count ocean Egyptian cotton. Her mouth, a mausoleum. Thinking, *Erzulie. Water. Shango. Fire.* Ideating death, resurrection, life, legacy. Her mama's worst fear.

And:

Everywhere. Light.

HEAVY ROTATION

I LET MY TAPE ROCK
TIL MY TAPE POPPED

INVOCATION WÜNDERBAR

Come Chicago, brick & bitter, lake wind blowing north on Wabash,
girls in bubble coats walking backward, boys smoking cigarettes pinched
between red fingertips, come cars, blowing blue exhaust, buses billowing
black smoke, billboards smiling down with their false advertisements,
come heater, knocking at night, come television, come double locks,
come snow boots, come gloveless hands and loveless gray afternoons.

Come muse, come nouns, come verbs, come Epson, come books and ex-
slaves with one eye seered shut for trying to read. Come reading, come
hours, come paper and pages, come hours, come paper and pages, come
vision, come paintbrush, scissors, glue, old book. Come Kahlo, come
Jean-Michel, come Andy, come Walker, come studio, piles of *National
Geographics*, clipped things, feathers, ripped signs, old art, come smoke.

& Jameson, Ohio Players, *Kill Bill*, aching knees, come, white candle,
come, rice, come letterpress, come Vandercook, come, binder's needles,
linen threads, inkjet, bone folder, come, quilter's skills, come thousands,
come, J*Davey and Kanye, come, come, femme fatale, paper bullets, pink
gouache, come, gold leaf, jars of water, come, time and breaks & bodies
& bodies

Of work, come, brilliance & fame and wealth, come, Clifton, Brooks,
Knight, Grandma & Grandpa Franklin, come, Charlie & Mary Ann
& Susan and Papa Sam, come, Margaret, Ginsberg & *Howl* and Kerouac
& Burroughs, come poems & poets & masterpieces & legacy, come,
Come, come, come, come, come, come . . .

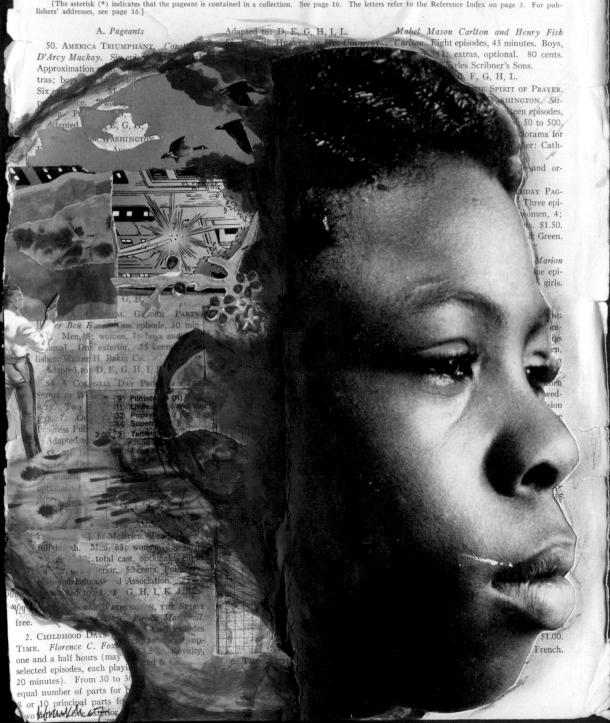

IT DO WHAT IT DO: (ME & HOMER TALK POETRY)

How can poetry save him now?
 —**Patrick Rosal**

i.

County blue is not vast,
not bright, but it sucks
you in and swallows
like a bird disappears
into nothing in the distance,
reappears in a new place,
to different eyes.

County blue is dingy,
washed out, overused,
a sharp navy whose edge
has dulled against the cutting
board of time. A blue that's
been buried and brought
back, a little death
still clinging to its hem.

I can't speak for the wearer
of this particular blue.
How does it feel to slip it
on each day? To tug at the slouch
of it as it creeps down your hips
like the hand of someone you're
sleeping with, but don't want
anymore, disgust hollowing
you like a cored apple. I'm sure
these words can't even approximate it.

ii.

Words are bridges. I don't tell
him that. The way we reach
for each other across them is enough.

We say it together, "e-pis-to-lary," then
dig into its heart for meaning
like kids goring the dirt with a stick.

It's here that the blue drops
away from him. We escape it
on words that are really nothing
but everything. Figuratively,
I hold his hand like I know
the route out when really
I am just as confused as he.
He is the one who guides
us toward the doorway.

iii.

There are no coincidences.
His name holds the *Odyssey*
in it, but I don't tell him
that because at his age
I would have stumbled
through those epic pages
like a fugitive in the woods
at night. My eyes would've glazed
over, and I'd be gone.

I want him here.
Cause I like the way his face
unfolds like a letter when he
unravels my tangled stanzas,
and asks me how to find new words.
I like the way his mouth cracks
into pure white light
that helps us see in this dark.

iv.

The dictionary is not a body,
it's a book. It doesn't bleed
or breathe or cry in its cell
at night. It doesn't swell
up or jump bad or swing
when someone gets smart.
It's just a book.

But when we open it—me
and him—all the words
tumble like a combination
lock in our minds, and we slip
out through the unguarded exits
they create. Not literally, of course,
cause at the end of this,
I'm the one leaving here.

He goes back to county blue.
But this time when he leaves,
he's clutching a thesaurus in his hand
like a shank.

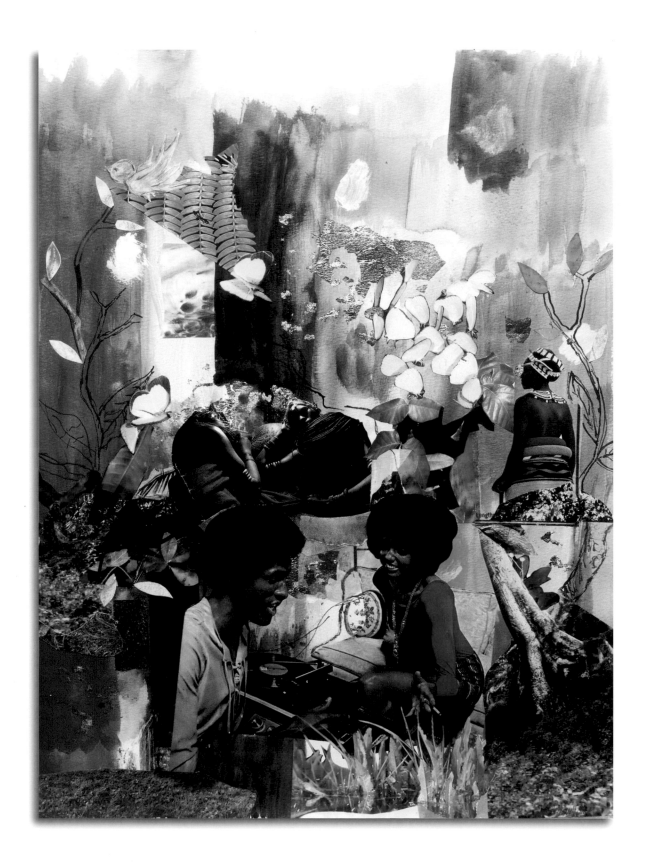

TAKING THE COUNTRY BACK
The Tea Party Pantoum

Once, there was a revolution
bright as death, explosive as fireworks
that birthed an idea
a newness, so baby pink

bright as death, explosive as fireworks
raw as uncooked meat.
A newness, so baby pink
I love how you bring that back.

Raw as uncooked meat
how you drag the past to present;
I love how you bring that back
the millennium becomes antebellum

How you drag the past into the present
with a twist of your tongue
the millennium becomes antebellum
pink as a newborn, red as uncooked meat.

With a twist of your tongue
the gatherings you throw like picnics
pink as a newborn, red as uncooked meat
plenteous plates passed, you picket.

The gatherings you throw like picnics
your signs, white and beautiful as God
plenteous plates passed, you picket
ink spilling into words crooked as cubism.

Your signs white and beautiful as God,
exquisitely illiterate, passionate
ink spilling into words as crooked as cubism
bumbling, bubbling with love of country.

Exquisitely illiterate, passionate
History: I adore your glistening nostalgia
bumbling, bubbling with love of country,
your sprawling plantations, your masterful erasure.

History: I adore your glistening nostalgia
the way white is brushed on all marred walls,
your sprawling plantations, your masterful erasure;
brown faces blister in your sun.

STORM RETHINKS HER POSITION

At my vanity, I brush the stars
from my hair, listen
to the bones of my friends
as they settle into their chambers.
One cough, wet as the clouds
I gather around me like children,
lands muffled on my ears.

Outside, Logan's bike roars to life, shrinks
to a small buzz swallowed in the distance.
(He roams until dawn, pacing
his pocked memory, lying in the hollows
hoping the darkness offers a clue of who he is.)
While the bristles move through, I mull
over Magneto's proposition, praying
the Professor has closed his mind for the evening,
that Cerebro has sighed herself to sleep.

There is sense in Magneto's position, this madman
whose body is a nest of the electromagnetic,
who makes a home for us higher than I've ever flown—
where Venus slowly rotates like a woman
appraising herself in her mirror.
All my life on this planet spent in service
of others, the elements that converge in my breast
for their protection bow to me like the small humans
in the village of my mother when I was a girl, a waterfall
spray of albino cornrows washing down my shoulders.

I try to remember a moment of humanity, a memory
not contaminated with hatred
(the kaleidoscope of genocide they spin before our eyes).
I think of the vow I made, the laughter of my family,
their magic crackling in the air around me,
and wonder what freedom tastes like.

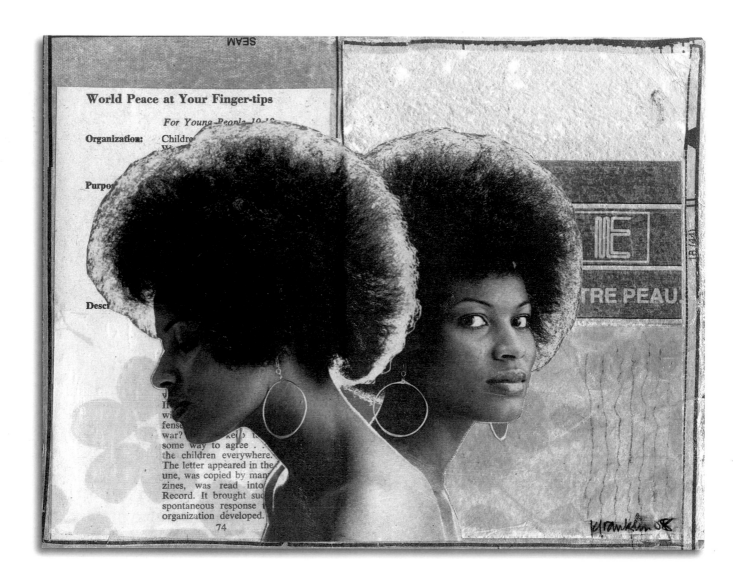

QUICK CALCULATION

One + ½ bottles.
My lover is fucked.
I'm climbing from the whole of forty-five years + one cigarette
+ a plastic ¼ cup of Apothic. The room is dark.
The cable is still on, a bad movie playing,
but not for long.
The ½-empty bottle of gin the poets left calls from the cabinet.
My insides ache.
My friends text.
Where are you?
How are you?
I'm thinking of you.
Are you okay?
I'm not.
But I do have bucks in the bank
for tobacco at Cut Throat
if things get as dicey as my insides.

+

I made a deal with the devil.
No sum total of lemons,
lemonade, or sweet tea
can cure that.
The amalgamation of all my still-alive
+ still life heroes can't stand in destiny's doorway.
None of us get out alive.

The internet moves slow.
The computer my ex bought is defective.
There is little here that I need.
+ I devour it all like a starving child;
mouth open, inhaling everything in sight.

The vultures circle + dive,
peck a decade cultivated in Ohio libraries

+ generations of mouths duct taped
with Black respectability. I keep my nails polished,
so it's difficult to see the dirt beneath them.
My mother warns, *you make it look so easy*.
Each morning I wake on sweat-soaked sheets.

The tarot shows me,
top to bottom, left to right: alone.
The Golden Girls is on, so there's a little solace.
My besties vanish for partners and children.
Nuclear dreams are more seductive than me.
I can't blame them.
Centuries of lies > a decade of truth.
I'm bad at math. That's quick calculation.

Khadijah says, *Sovereign. Sovereignty*,
a hypnotist's chant, her index finger runs waxy surface.
She needles a masterpiece of my flesh,
my blood back from sycophants.
Seduces my spirit to slip back through the cracks.
Her laugh past the closed door.
I watch her Cheshire cross-legged through rheumy gaze.

Pathology. Pathology. Pathology.
Pain. Death. Agony.
30 degrees + wide-open window.
I spend days smoking out air thick
with the rage of ghosts. Drug addicts
+ drunks serenade ½ past 3 a.m. at
my windowsill. I lay in their blue haze
of mid-mourning, wide-eyed,
terrified, an amethyst tight in right palm.
I quietly tap my DNA's tight drum,
draw a white circle + wait for sleep's slick embrace.

The Man who Immortalized Purple
is snatched into ether. The Woman
who immortalized Purple is a licked wound
of Bad Mother.
All mothers = bad.
All fathers = free.
Binaries = blinding.

I stand close-eyed in the heart
of a gallery's dim deep purple
+ listen to cacophonic whispers
of animated paintings. My eyes open.
Close. Listen. Open. My gaze turns
to those that speak the loudest.
Their eyes radiate,
unsmiling in dim light.
Smile. They say, *we are working*.
Burning. They say, *Sorcery*
+ *Alchemy*. They say, *Daughter*.
Seer. Come closer.
The room is a crossroad.
I am *Veve* + chalk line.
A cross-hatched warning.
A threat. A map. An omen.

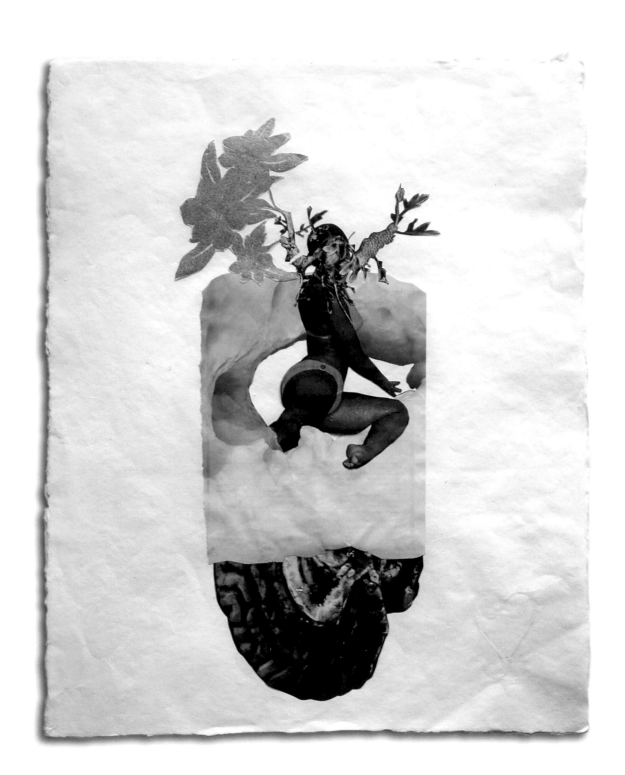

SNARE

"Jimi often told a story about a girl who tried to ensnare him with voodoo . . ."
 —Harry Shapiro and Caesar Glebbeek

"Whatever it is that girl put a spell on me."
 —Jimi Hendrix

i. *tincture*

1. rivulet of Stratocaster sweat
2. thimblefuls of dust
3. spit
4. one shard of broken guitar pick
5. two strands of hair
6. stolen fuchsia scarf
7. one shot of rum
8. one lit red candle
9. one plucked wing of nocturne
10. two mason jars of river water
11. one handful of bright eyes
12. one drop of blood

ii. *alchemy*

I loosened the scarf
tied around his thigh
with my teeth
in a roomful of people
while we sat on a blood-red sofa
getting high
he laughed
I leaned back
slipped the fine fabric
from his leg with my fingers

when I looked at him
a shutter snapped
burned a light of his inside me

I wanted an infinity to lie under
the crescent moons of his eyes

after that
my nights were furious
dreams, full
as a nine-month womb:

a running white coyote
I chased through a desert
a jade-eyed cat
jaunting toward me
where I reclined
beneath a peach tree
he meowed once
coughed a small ball of guitar string

a woman in a turquoise veil
passing by me
whispering something
I can't remember

iii. *oracle*

the unconscious door
is ajar
one breath
blows it open

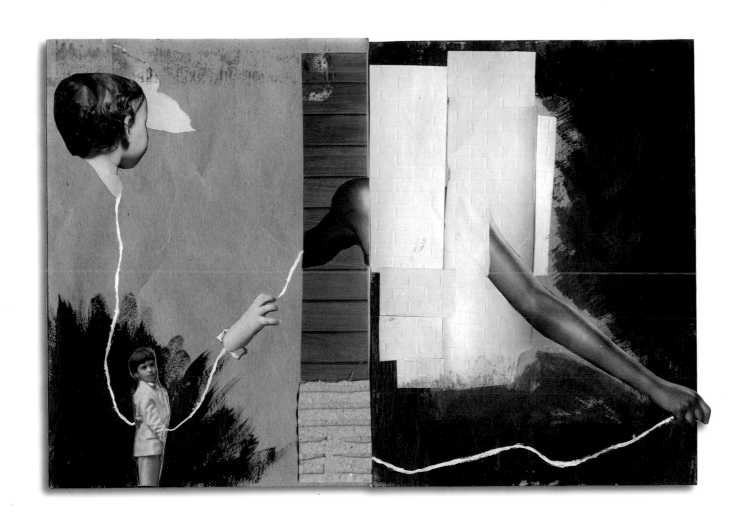

TATTOOING THE MOTHERLINE

I am possessed by Eros,
leaning back in a black leather armchair
that squeaks when I move.

A steady-hand girl
who shares my zodiac
penetrates the freshly-shorn

thin brown skin of my upper arm
with an ebony-ink-dipped needle,
sharp as the arrow of Cupid.

She and I talk shop
over the low humming,
the tiny pricking and dragging

of her stylus fingertip
engraving me with the names
of three generations of women

who walked the long path
to get me here.
When her moving hand becomes uncomfortable,

I flex my toes to feel
the slapping of my sandal
against the sole of my right foot,

and lose myself in the funk
of the Ohio Players thumping
from the small gray speakers

that rest on a table
in the far corner
of the white room.

When she is done,
we admire the elegance
of my angry, scripted bicep

slick with Vaseline,
and step outside
for a smoke.

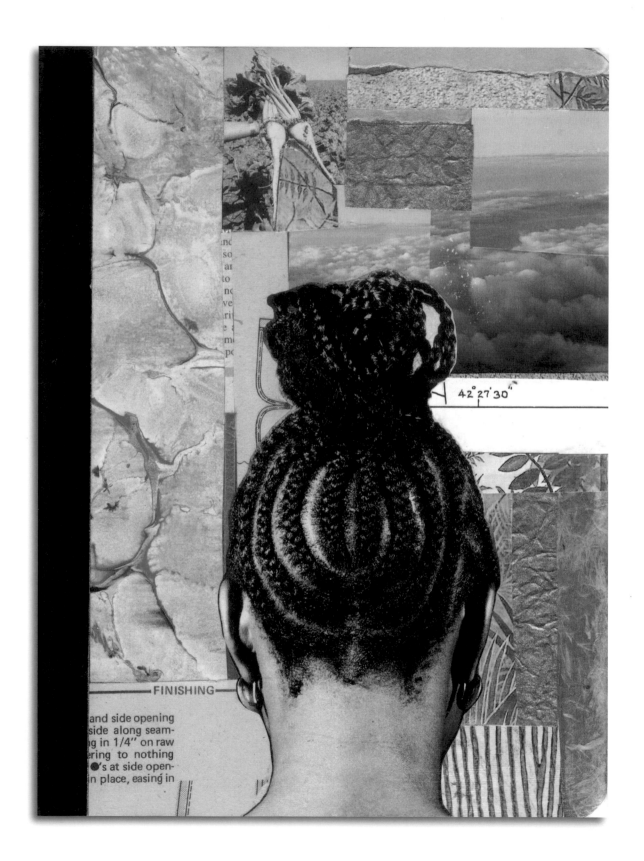

HISTORY, AS WRITTEN BY THE VICTORS.

The world is burning. Listen to Minnie Riperton on cassette tape. All of the records are in flames. The archives in ashes. Blood pools in the gutters of the streets. A Black girl in a pair of '85 Air Jordans levitates down the block. She is clutching a copy of *The Red Record* she transcribed by hand, *The Book of Eli* in her backpack. All the buildings are boarded with eponymous red Xs on their Third Eyes. The house where Muddy Waters lived is broke down. Johnson Publishing is as stripped and gutted as a woman of ill repute. The invisible fences between neighborhoods are electric. Howlin' Wolf is growling from the mouth of a seventeen-year-old on 71st Street squatting in the wreckage of Sun Ra's mothership, mumbling, *I'll feel better if you understand. You won't listen to me.* Black Youth Project 100 is holed up in an architectural effigy they psychically constructed of the house where Fred Hampton was murdered. A transgender fourteen-year-old in their ranks is finger painting AfriCobra murals from memory on the walls with looted Kool-Aid packets and bottled water. A cluster of hooded teenagers is reciting lines from Gwendolyn Brooks's poems in unison at the top of their lungs on the porch. *Remembering, with twinklings and twinges.* A freshly shorn Chief Keef speeds by on a dune buggy in a wasteland he created with his own hands. The north side is surrounded by CPD in riot gear. White people there haven't seen the sun for decades.

This is Chicago as we know it, knew it, know it, knew it. Time is an illusion. Depending on the body that you live in, history is slippery as memory. All of it is a series of concentric circles. The question is where do we connect? And when? Imagine your mitochondria as a listing of names in a chattel slave ledger, or numerical assignment in an interment camp. Suppose your body a record of undocumented workers, or five generations of the spoils of war. Envision yourself booty, Loose Booty, walking the streets—the unholy offspring of poets and mass murderers, both colonized and colonizer intertwined in your cellular structure like an unpruned rosebush around a rotten trellis. What of history then? Think of the body—your body—as encyclopedic volume of one thousand years of experiences. In the middle of a book you have yet to crack exists facing pages, a story of the bludgeoned on one and the bludgeoner on the next. It's all one story; the *Book of the Dead*, the *Book of Life* nestled next to each other like sleeping children. They are dreaming dreams in your bloodstream.

Which side do you choose? What if you don't have to choose? These wormholes we call History and Time are the chronicle of near-Biblical lies based on scientific fact. What happens if we wrap our arms around all of it? The Dead, the Living, the Soon Come, all the same time and space. The Good, the Bad, the Ugly, the Sinners and Saints, all inside us at this moment, right now. What if I looked you deep in your eyes and said, "You are the war-torn and the war monger. Both the land locked and the astronaut." And what does it matter? All of the history books are piled up and molding on the cold floor of a closed school anyway, and the average American couldn't tell you the top news story last week, much less comprehend the psycho-sociological importance of bringing down and burning every Confederate flag ever made and raised in this country. The room is divided between shoulder-shruggers and angry-faced emojis. God Bless America.

What we believe is this: The wasteland is the compost of the Now. The Future is already here, crawling, tottering like a drunk in the alleyways of time, walking like a sophisticate, running in the shadows with his pants slung low as a gunslinger. The final frontier is between your ears. It is post-apocalyptic dystopia or utopic bliss depending on your position. We can stand in the sun or crouch wounded in the dark; regardless, it's all of our making.

We are major manifestors. Our DNA contains the skeletons in history's closet; our left foot is slave, our right is slave-driver. These clouds of high-energy electrons are not static objects. Nothing is static. We exist in a continuum of time that is ever evolving, ever changing. We do not need to reinvent the wheel nor re-form the weapons. The moon and the sun go on playing an eternal game. We are natural phenomena engaged in an unhallowed battle with our Mother. Time is not a line, it is a series of concentric circles. It is also an illusion constructed to induce us to consider the concept of progress as an intellectual exercise. Progress is a verb. The only universe we control is the one between our ears.

Our ancestors said, *we shall not regard our swelled head as a sign of real glory for shadows fade at evening*. They asked us, ARE YOU LIGHT OR VERY DARK? We know that this is not an inquiry about flesh. We do not worry about history because we look into history's eyes when we brush our teeth in the morning. We flush streams of history down our toilets, throw chunks of it up when we drink too much gin. History digests our lunch. We blow history out of our nose. Even in this moment, history inhales and exhales, a secret agent and innocent bystander.

We believe that walls are witnesses. As are trees, and street lamps lined along I-94. Even blue boxes, blind and blinking, carry our stories.

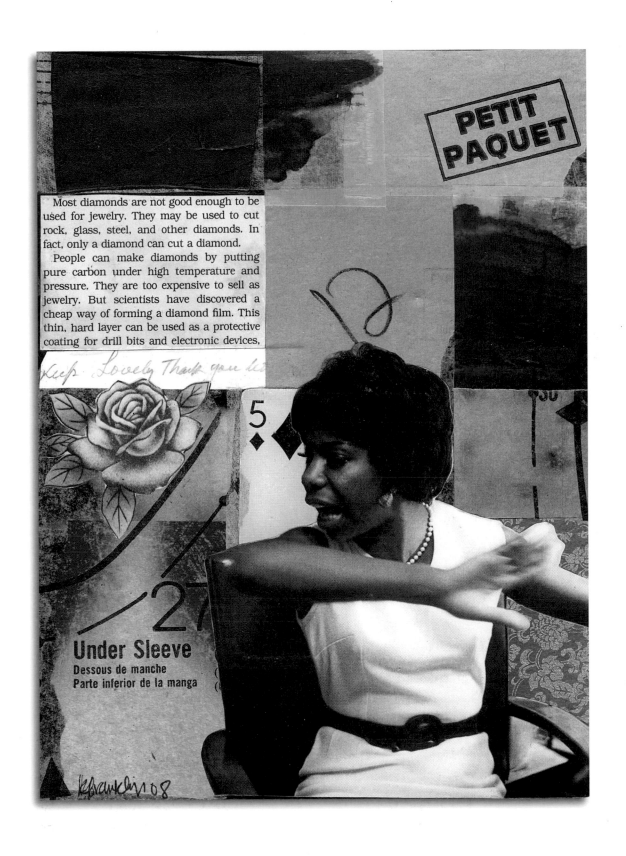

PETIT PAQUET

Most diamonds are not good enough to be used for jewelry. They may be used to cut rock, glass, steel, and other diamonds. In fact, only a diamond can cut a diamond.

People can make diamonds by putting pure carbon under high temperature and pressure. They are too expensive to sell as jewelry. But scientists have discovered a cheap way of forming a diamond film. This thin, hard layer can be used as a protective coating for drill bits and electronic devices,

keep Lovely Thank you

5 ♦

27

Under Sleeve
Dessous de manche
Parte inferior de la manga

kfranklin 08

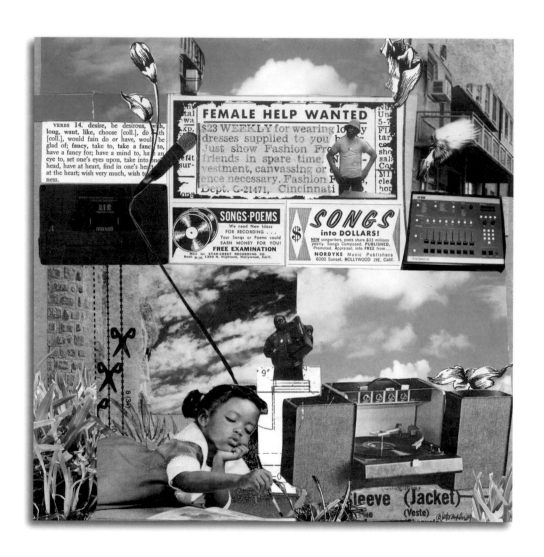

3037, TIME CAPSULE: FRANKLIN

You will discover it shining in the red dust
of Mars [Earth a twinkle
in your mama's eye] inside: a black
& white photograph of an old yellow woman
in a lawn chair her left bra strap slipping
down the side of her arm, a collapsed smile;
an unopened pack of American
Spirits; an embossed note saying: Folks don't believe
fat meat is greasy; a folded-up article
from *Art in America* spilling stardust & sassy
blk clipped phrases; withered petals of what used
to be honeysuckle; an X-ACTO knife; a thank you
note; a plastic mask embellished with blue
feathers; a church fan, John 3:16 blind
embossed on its front; an empty bottle
of Cabernet corked, a rolled sheet of abaca
in its innards, on it written: find the nearest body
of water & set me adrift

CALL

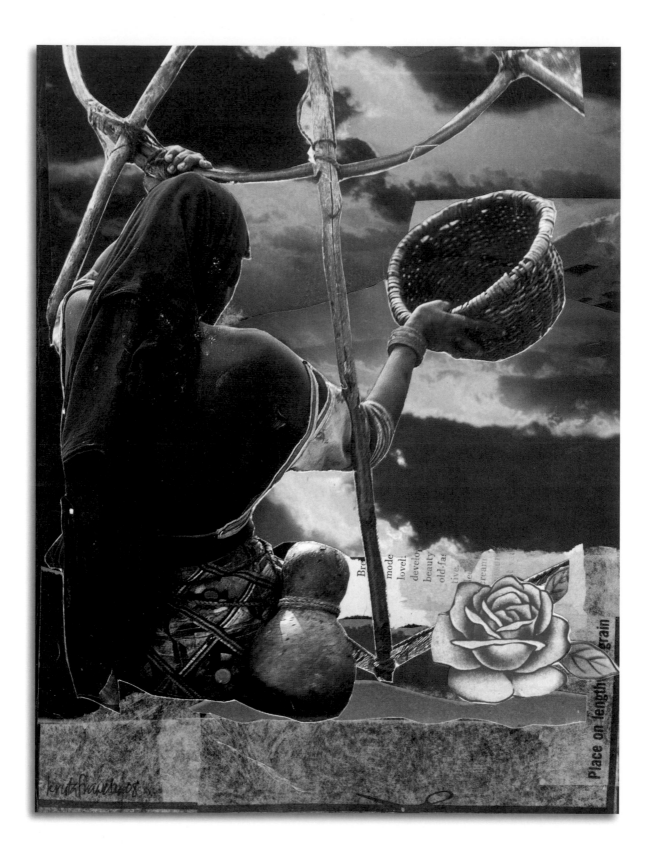

CALL

For the new images. The new visions. That new New. Those ideas that unfold life like newborn fingers unfurl to grasp your fat finger. Images that beckon your gaze like a soon-to-be lover. Images that break like dawn, slice death down with a barrage of paper cuts. No more boots on necks. No more nooses. No more gasps for air, no chokeholds, no more mobile videos of backs blown out in open fields, no more women's hands poking through the broken slats of misogyny's dungeons. No more teddy bear totems and elementary school photos on the five o'clock news. No more "It's not me," no more "It doesn't affect me," no more "Tsk-tsk," no more tears, guilt, and Twitter trolls.

It is You. Here's a mirror. Look behind You, beyond You. Here's a portal. Jump through it. Make Magic. Follow the breadcrumbs, the North Star, the scary crackle of tree branches just ahead in the dark. Take the darkness into your fists and smash it on the warm stones of Daylight. Make Daylight. No more caskets for us to all crawl into. No more remixed autopsy recitations, no more black-masked mammies, no more brown bodies on your cooling boards and studio floors, no more satirical snark crafted to suffocate. No more grabbed bodies, no more public/private intellectual masturbating, no more twentieth-century icons as Dead Talking Heads to Justify Injustice.

Artists, Writers, Intellectuals, Inventors: Tina Turner already told you, "We don't need another hero. We don't need to know the way home." Make a new home. A twenty-first century vision. A future image. Get up from the Banquet Table of The Feast of American Madness. Wipe your mouth and turn the entire table over. Grab the hand of the person next to you and make a break for it. French kiss the idea of Humanity. If You find Your imagination cannot stop itself from churning out the scripts of the Death Machines, pull its plug. Dismantle it. Reprogram it. Dream Daylight. Manufacture Daylight. We are the Magicians.

Make Magic.

INTERVIEW

SELECTIONS FROM THE ARS POETICA
AND ORIGIN STORY OF KRISTA FRANKLIN

TEMPESTT HAZEL

At twenty-one, I stood at the crossroad of Hell
& Here, evil peering at me behind a blue-red eye. I armed
myself
with the memories of Pentecostal tent revivals, apple
orchards, the
strawberry fields I roamed with my mother & aunts in the
summer
& the sightings of UFO lights blinking in the black of an
Ohio
nightsky. I am a weapon.

> **—Krista Franklin, from "Manifesto,**
> **or Ars Poetica #2"**

Franklin is a storyteller and a vessel for well-known histories, things unwritten, and realities that have yet to be, which is why defining her as only an artist or a poet is inaccurate. Her work demands that those titles be interchangeable with historian, educator, caretaker, life scholar, ethnographer, anthropologist, and receiver.

Franklin reveals herself as a master sampler who builds bridges between a vast range of elements and references within a profound sea of influences and experiences. Each work comes with its own list of liner notes and citations. To describe her work, I could as cite the poetry of Fred Moten and Amiri Baraka, writings of Ishmael Reed, or the worlds of Octavia Butler as I could the collages of Hannah Höch and Romare Bearden, or the chameleon-like characteristics of Grace Jones or Prince Rogers Nelson. I could use the lyrics of Bad Brains, the album covers of Parliament/Funkadelic, the music videos of Outkast, or the echoing sound of voices that linger above 47th street in Chicago on any given day to bring it back into a place of Black sonic culture. In the same breath, I could speak about the recurring lyrical and visual motifs that show reverence for the grace of Black women, youth, and street scholars while channeling the supernaturalness of veves, afro picks, cowry shells, and global Black memorabilia.

Franklin offers traces, not a blueprint. She is an artist whose style and technique is often imitated but never duplicated because her radial disposition is organically constructed through insatiable curiosity, instinct, and learning through living, making her process and approach distinctly her own.

TEMPESTT HAZEL: Since you're such a pillar in Chicago some people may think you're from here when, in fact, you're from Dayton, Ohio. What was it like growing up there?

KRISTA FRANKLIN: I grew up in a racially mixed suburb in Dayton, Ohio. The majority of my friends and neighbors were white, which, for the most part, was a non-issue for everyone around. It was fairly idyllic. We all played together, rode bikes together, went swimming together, went roller-skating together, danced, and did homework together. We were all up at each other's parents' houses listening to music, watching TV, or whatever. What I remember most about growing up in Ohio has been chronicled in a lot of the poems I've written. I remember there being a lot of space; space to think, space to breathe, space to roam. The natural world was pretty prominent where I grew up, so trees, the woods, birds, creeks, minnows, deer, raccoons, possums, cats, dogs, cornfields, all that was present. There was also a good deal of quiet time. It's slower than Chicago, so you don't have a whole lot of distractions. If you want distractions, you have to create them.

I had a lot of freedom growing up in Ohio. I often think about and mention all of the brilliance that's

come out of Ohio in general. Nikki Giovanni, Toni Morrison, and Rita Dove were all reared in Ohio. One of Dayton, Ohio's, claims to fame is that it's one of the seats of funk music—Ohio Players, Slave, Heatwave, Lakeside, Zapp featuring Roger (Troutman)—all out of Dayton. The Wright Brothers set one (if not the) first flight into motion in Dayton, Ohio. Ohio is a magical place to grow up really.

I'm convinced that the reason that I'm the artist and poet that I am has everything to do with being Ohio born and bred. Ohio is not without its troubles and pathologies, but growing up there and coming of age there in the '70s, '80s, and '90s deeply shaped and impacted the way that I see the world, the way I move through the world, and the way I process things.

TH: When did you first suspect that you might want to make a career as an artist?

KF: I never know the answer to this question because I always wrote and made art since I was very young. I would write poems as a teenager and then read them to my mother while she was doing her makeup or cleaning the house. My whole family knew that I was an artist and would always call me a bohemian, but there were no models or maps for how people became professional artists in my family. It was always seen as my "hobby," and my mother, father, aunts and uncles were always asking me what was I going to do for a living and what I was going to grow up to be. I didn't even think being a professional artist was possible, but I thought that I could probably figure out how to write for a living (as a journalist). In undergrad, I started writing pretty seriously and publishing and studying, and developing a political consciousness around Pan-African issues. I hung out with designers, musicians, photographers, and poets, and I spent hella hours in the library combing the stacks. I was just living really. I had no idea what I was going to be for years.

Sometimes I think I still don't know.

There was really no one definitive moment when I decided to make a career as an artist. It was a series of moments, experiences and people who encouraged me, and told me that my work had merit. I followed that impulse inside of me to make and write, and somehow I landed here.

TH: When did poetry first enter into your life? What poets and writers have been significant influences on you?

KF: It first entered my life in those poetry recitation competitions in elementary school. However, my mother and her sisters were teachers in various capacities, and my aunt Maria in particular had a wonderful collection of books that I would browse and there were a lot of Black poetry books I was exposed to early. My mother also wrote poetry for fun; very traditional rhyming poetry that she would read to the family. Most of them were funny because my mother has a great sense of humor and likes shenanigans. There was always a lot of singing and reciting of poems between my mother and her sisters, and I was exposed through them to the art of transforming memory into art through storytelling and clowning around. It was all really quite poetic.

On Christmas of my seventeenth year my mother gave me *The Selected Poems of Langston Hughes*, and I spent that entire day reading that book. It was the "A-ha" moment for me around poetry. I remember just feeling this joy around that writing and around what words could do in a concrete way. The other writers and poets who were very influential on me early on were S. E. Hinton, Judy Blume, Gloria Naylor, Alice Walker, Toni Morrison, Sonia Sanchez, Nikki Giovanni, James Baldwin, Audre Lorde, Isabel Allende, Greg Tate, Amiri Baraka, William S. Burroughs, Anne Sexton, Erica Jong, Willie Perdomo, Octavia E. Butler,

Katherine Dunn, Philip K. Dick, I could go on and on. I would also be remiss if I didn't talk about the influence that hip-hop MCs had on me and my writing and art: Chuck D (of Public Enemy) served as one of my most significant writing influences. There are many, many others though.

TH: Anyone who has heard you read your poetry knows how captivating of an orator you are. Is this something that came natural to you?

KF: I don't believe in oration coming naturally. If someone is a good performer or orator you can pretty much guarantee that they practiced to be so. Again, I learned as a child in those dreaded poetry recitation competitions, but I also learned a lot from preachers in church, and from the women in my family who were constantly "performing" for each other through telling stories and sharing memories with each other in a very dramatic and hysterical fashion. Also, listening to all kinds of music, but hip-hop in particular, taught me a lot about how to emote and move a crowd.

TH: When did visual art make its way into your practice?

KF: Visual art was always a part of my practice, even in my poetry. I always talk about my poetry being in the "Imagist" tradition. I believe that the most powerful poems are pictures painted with words. I always drew and doodled and made images on paper even as a child. My mother still teases me to this day about how I always had some "project" I was working on. I had this series of small books I created as a child using an ink pad and my thumb print. I would draw images around my thumb print. I think the series was called "Thumbody Loves Me," or something terribly corny like that. I may have even been trying to sell them to people.

I began seriously making mixed media collages in

my mid-twenties, and it was something that I did when I was afflicted with writer's block. However, it wasn't until I moved to Chicago and other artists and poets became aware that I was making them that I put them in the public eye. It was really at the encouragement of my artistic community that I even considered exhibiting and showing my visual art. It was always just my little thing that I did for myself to shake the words loose in my brain; the pathway to more poems.

TH: It's clear that music is important to you—Chaka Khan, Ohio Players, Michael Jackson, 2Pac, J. Dilla, and so many others have appeared in your words and visuals over the years. Can you talk about the role music plays in your work?

KF: Music is the underscore for everything I do. It's the pulse of everything I make and write, really. I don't even have a clear way to articulate the role that music plays in my work. It's such a non-factor because it's just so present. For years I was the girl who had the most formidable music collection of any of my friends. I mean, the music industry probably earned hundreds of thousands off of me throughout my life. Seriously. My visual aesthetic was cultivated by my father's album collection in the 1970s and videos on MTV and BET in the '80s and '90s. My poetic voice was partially cultivated from listening to hip-hop MCs, R & B, and rock songwriters. My love of music is its own art form and art practice. The way it shows up in my visual art and poetry is just a by-product.

TH: What experiences have been most transformative for you in terms of residencies, readings, travel, exhibitions, education, conversations, etc.?

KF: This question is a great one, and to be completely honest with you my entire life has been a series of

transformative moments and experiences. I've had passing conversations with homeless people that have completely turned my top. I've read books that blew my imagination into other realms. I've been befriended by some of the most brilliant minds of my generation (to riff off of Ginsberg). I've been healed by women laying their hands on me and uttering prayers and poems and incantations. I've had men who I thought stepped out the pages of my favorite novels stare me in my eyes and say profound things to me. I've been driven to tears in pure ecstasy playing music in my car on the freeway. I've had people I deeply respect and admire greet me warmly when they see me in the streets. I've had the honor of teaching and working with some of the most powerful artists, writers, and activists of this next generation. Some days, the realization that I'm still alive and can find moments to laugh with abandon in this brutal world is a transformative experience to me. The residencies and readings and travels and exhibitions and education are all just icing on a very rich layer cake.

TH: Is there a different pleasure that you find in poetry versus paper and printmaking?

KF: I've never really thought about this, but I don't think so. It's all labor to me—writing (or constructing) and revising a poem, going through the various steps of the papermaking process, and the letterpress process. The letterpress process for me is more of a communal process because I'm never doing that alone, so maybe there's a different pleasure in that I'm in community making something collectively. But even with poetry at some point I'm in community sharing what I've written so there's still other people at some point in the game. I think it all comes with a similar pleasure though, or at least from the same life force/ source. I will say that papermaking and letterpress are more kinetic to me. I often equate those experiences with dancing, and I often dance when I'm making

paper or letterpress pieces. It's all wonderful though, even when it's challenging.

TH: You've already touched on this a bit, but in what ways does your family manifest in or influence your art making?

KF: Oh, my family have always been a huge influence in my writing, and they have appeared in various forms in my poems. The common understanding is that most poets' first books are about their family. I would probably go so far to say that the first two manuscripts (unpublished) that I wrote and put together were completely about my family and my relationships with them. But when it comes to my art practice in general one has to understand that I come from a working-middle class Midwest family, and work ethic is just par for the course, whether you're working at a job for someone else or working for yourself and your art. So if there's any one way they have manifested and/or influenced my art making it's in the work ethic and the determination for excellence on all fronts. My parents did not find slacking or playing around in my studies and endeavors cute at all. There was a high standard expected of me in all things, and if I was caught slipping there was going to be hell to pay. They conditioned me to be about Black excellence, and it was a frequent saying in my parents' house, "Don't misrepresent us." They were about representing before I even heard the term in hip-hop. It was not a game to them! So the work ethic is the main family manifestation, but they appear in other forms, both overt and covert.

TH: What are some unexpected or hidden influences on your work?

KF: I'm not sure if there are any, and if there are they are completely hidden from me too. I think most of my influences are pretty transparent or already

listed/named. However, there may be some people who don't know that I'm a serious film lover, that video and the moving image in general have a big influence on my thinking and art practice. I actually find people who leave a movie before the credits have finished rolling to be quite rude. I read film credits like I read album liner notes. I'm always looking for the names behind the images. Many of my good friends laugh at me when I start talking about directors and cinematographers I love and what movies they've done, and folks' filmography. I mean, even with television shows I love I'm like, "Who directed and wrote this episode?" Music videos too. If I see an aesthetic that I love I have to figure out who that is and do all the research. I'm real ridiculous when it comes to that. So there are a number of movie and video directors who are influences on my work, but I'm not sure if their influences can be tied so clearly or directly to what I make or write.

TH: Your influence as an artist radiates not only through your peers and the people in your constellation, but also through teaching, which is something that you are deeply committed to. Where have you taught and why is teaching so important to you?

KF: I've taught all over the city of Chicago, but mostly as a poet and teaching artist. Some of the places I've taught are Young Chicago Authors, Neighborhood Writing Alliance (now defunct), El Cuarto Año Alternative High School, Art Institute of Chicago, Museum of Contemporary Art Chicago, and Gallery 37. There's actually not too many organizations or institutions in the city of Chicago that I haven't worked for or with at one point or another over the past fifteen years. As far as teaching is concerned, I come from a family of teachers so it's just a part of the family legacy really. The more I teach the more I'm

convinced that I'm in the work of teaching for what I can learn. I say it all the time: I learn far more from the people that I teach, be it children, teenagers or adults, than they learn from me. Teaching is actually a part of my own educational process as a human in the world. I could tell you some kind of altruistic reason for why I teach, but in all honesty my teaching practice is a purely selfish endeavor. I teach to expand my own thinking and knowledge base about the world around me. Almost every group of people I've been in a "classroom" with has taught me something new about what I thought I knew, whether they were three years old or seventy-three years old. I'm actually just out here gathering information from all the master teachers through masquerading as a teacher myself.

TEMPESTT HAZEL is a curator, writer, and founding editor of Sixty Inches from Center, where you can read the full interview. Her writing has been published in the *Support Networks: Chicago Social Practice History Series*, Contact Sheet: Light Work Annual, Unfurling: Explorations In Art, Activism and Archiving, on Artslant, as well as various monographs of artists and exhibition catalogues. tempestthazel.com

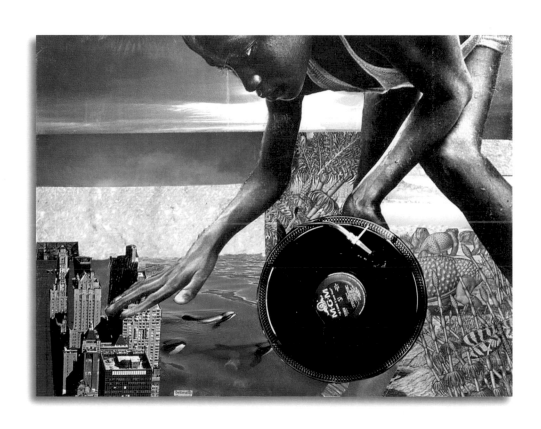

ACKNOWLEDGMENTS

Thank you to the editors, publications, and galleries that presented these works first or in previous forms. From *Study of Love &Black Body* (Willow Press, 2012): "Saturday Night at the Bug Inn," which also appeared in *Gathering Ground: A Reader Celebrating Cave Canem's First Decade* (University of Michigan Press, 2006), "Lucitdity: Ars Poetica," "Study of Love & Black Body," "Extrapolating Motherhood," "It Do What It Do (Me & Homer Talk Poetry)," and "Snare."

From *Killing Floor* (Amparan, 2015): "Manifesto, or Ars Poetica #2," "Drone: Ecology," "Killing Floor," "Black Bullets," "Definition of Funk," "Call," and "After Rashid Johnson's 'Self-Portrait Laying on Jack Johnson's Grave, 2006'." "After Rashid Johnson's 'Self-Portrait Laying on Jack Johnson's Grave, 2006'"" and "Promised Land" were written in response to works of art that appeared in the exhibition "Rashid Johnson: Message to Our Folks," April 14–August 5, 2012 at the Museum of Contemporary Art, Chicago.

In *Poetry*, "Manifesto, or Ars Poetica #2." This poem also appears in *The BreakBeat Poets: New American Poetry in the Age of Hip-Hop* (Haymarket Books, 2015). "Manifesto, or Ars Poetica #2" is part collage poem that contains lines from poems by Wanda Coleman, Aime Césaire, Amiri Baraka, Tim Seibles, Erica Jong, Lucille Clifton, Krista Franklin, album titles, movie titles, song titles, book titles & a quote from Bruce Lee.

"Tattooing the Motherline" appeared in *Bum Rush the Page: A Def Poetry Jam* (Three Rivers Press, 2001) edited by Tony Medina, Louis Reyes Rivera, and Sonia Sanchez.

"History, as Written by the Victors" appears in *The Offing* and *The End of Chiraq: A Literary Mixtape* (Second to None: Chicago Stories)(Northwestern University Press, 2018), edited by Jevon Jackson and Kevin Coval. It also appears in the film *Les Impatients* by Aliocha Imhoff & Kantuta Quiros. "History, as Written by the Victors" contains lines from Gwendolyn Brooks, Howlin' Wolf, Oliver Pitcher, Bob Kaufman, Aimé Césaire, Flavien Ranaivo, Wole Soyinka, and Winston Churchill.

"Drone: Ecology" was written for a reading that accompanied "Queen Bee," an exhibition curated by Allison Glenn for Terrain Exhibitions, Chicago, September 2015. The exhibition featured visual art by Krista Franklin, Victoria Martinez and Erin Minckley Chlaghmo. Performances by CM Burroughs, Lise Haller Baggesen, Rashayla Marie Brown and Krista Franklin.

"Black Bullets" was commissioned by artists/filmmakers Amir George, Erin Christovale, and Martine Syms, and was inspired by a film by Jeannette Ehler titled *Black Bullets* as well as the police murder of Mike Brown. It was first published in the catalog *Black Radical Imagination* (Dominica Publishing, 2015). "CALL" was written and published as a Risograph printed contribution to *People's Pamphlets*, an edition of artists' brochures curated by Jessica Cochran on the occasion of Printers' Ball, June 27, 2015 in Chicago.

"Storm Rethinks Her Position" appears in *Drawn to Marvel: Poems from the Comic Books* (Minor Arcana Press, 2014).

"The Ars Poetica and Origin Story of Krista Franklin" is a fall 2016 interview published at *Sixty Inches from Center*.

"Never Can Say Goodbye" appeared on *Unable to Fully California* by Larry Sawyer (Otoliths, 2010).

GRATITUDE

Thank you to my parents, Charlette and Matthew, always, for believing. Maria, Bunni and Barbara, Allen, Ricky, Robert, my cousins, Kerry, Kevin, Kapri and Rob, my sister Nakeyia and nephew L J for foundational love. To Kevin Johnson, Tanya Armour, Folade Speaks, Tracie D. Hall, Maria Eliza Osunbimpe Hamilton Abegunde, and Toni Asante Lightfoot, Ayanah Moor and Jamila Raegan Moor, avery r. young, Maritza Cervantes, Shirley Alfaro, Marta Garcia, Cheryl Reese, April Sheridan, Khadijah Kysia, Diamond Sharpe, Erika Dickerson-Despenza, Fatimah Asghar, Jamila Woods, and Dimress Dunnigan for seeing me and loving me anyway. Aricka Foreman, Phillip B. Williams, Tarfia Faizullah, Tricia Hersey-Patrick, Eliza Myrie, Angela Davis Fegan, Claudia Fegan, Miguel Aguilar, Alexandria Eregbu and Devin Cain (*du monde noir*), RJ Eldridge, Cauleen Smith, Greg Tate, La Tasha Nevada Diggs, Duriel E. Harris, Ernesto Mercer, Ruth Ellen Kocher, Tisa Bryant, John Keene, Eric Williams, Mecca and Medea Brooks, Kara Allen, Gloria Talamantes, Tempestt Hazel, Belinda Cervantes, Carmen Cervantes, John Germinaro, Kelly Norman Ellis, Parneshia Jones, Fred Sasaki and Katherine Litwin, André Hoilette, Lorna Hoilette, Michael Haeflinger, Danielle Rosen, Nicole Pritchett, Darlene Jones and Jordan for unyielding support, inspiration, fearlessness, insight, beauty, and compassion.

Big, big love and respect to Maya Marshall and Kevin Coval for visualizing, editing, and shaping this collection.

Front Cover
 Never Can Say Goodbye, 2010

GALLERY

Endleaves
 Two Thousand & Thirteen
 Narrative(s) of Naima Brown,
 2013

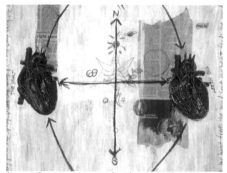
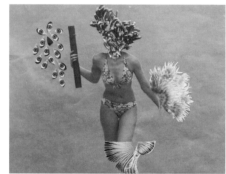

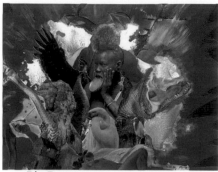
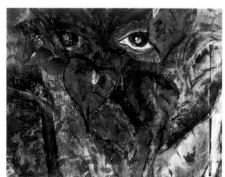

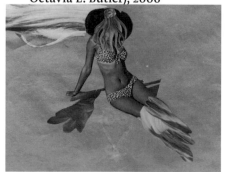

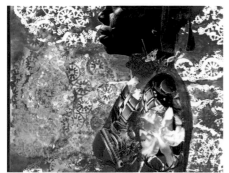

24 Do Androids Dream of How
 People are Sheep?, 2011

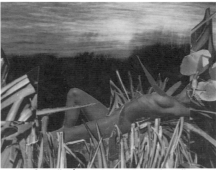

40 After "G/gnosis II Discipline"
 (for Ruth Ellen Kocher), 2009

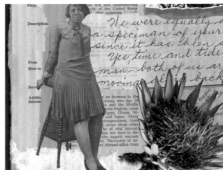

48 Ode to Marie, 2006

28 If You're Still Burning,
 Keep Breathing, 2006

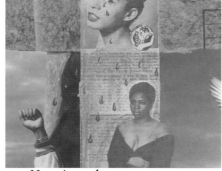

42 Totems, 2008

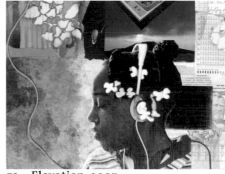

50 Beads and Barrettes

30 Oshun as Ohio Player(s), 2012

44 Mass Appeal, 2011

52 Elevation, 2007

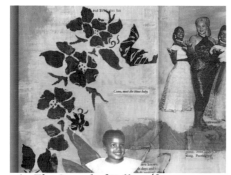

36 The Sound of Yellow (for
 Linda Susan Jackson), 2007

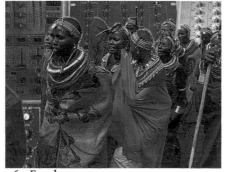

46 Exodus, 2009

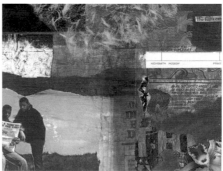

54 On the Blk Hand Side, 2006

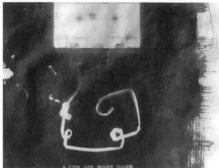

60 I Let My Tape Rock, 2012

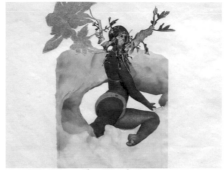

74 We Wear the Mask I, 2014

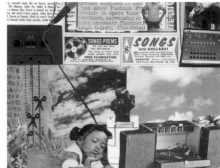

84 Hip-Hop by Default (for
 UNMUVABO), 2009

62 Manchild in the
 Promised Land, 2007

80 Urban Math, 2006

88 Violet Harvest, 2008

66 Lush Life, 2009

77 Kindred (from SEED: (*The Book of
 Eve*) for Octavia E. Butler), 2006

97 Transatlantic Turntablism, 2008

70 World Peace at Your
 Fingertips, 2008

83 Diamonds are Forever, 2008

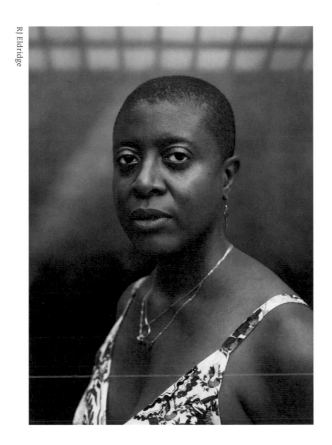

RJ Eldridge

KRISTA FRANKLIN is a writer and interdisciplinary artist. She is the author of *Under the Knife* (Candor Arts, 2018) and *Study of Love & Black Body* (Willow Books, 2012). Franklin is a frequent contributor to the projects of fellow artists, including performances, prints, and voiceovers for the projects of Cauleen Smith, and the text for Ayanah Moor's "Untitled (OFFERINGS)." Franklin is a main character in *Les Impatients* by Aliocha Imhoff & Kantuta Quiros, and her visual art has been exhibited at Poetry Foundation, Konsthall C, Rootwork Gallery, Museum of Contemporary Photography, The Studio Museum in Harlem, Chicago Cultural Center, National Museum of Mexican Art, and on the set of 20th Century Fox's *Empire*. Her writing has appeared in *POETRY*, *Black Camera*, *Copper Nickel*, *Callaloo*, *Vinyl*, *BOMB* Magazine, *Encyclopedia, Vol. F-K* and *L-Z*, and multiple anthologies. She holds an MFA in Interdisciplinary Arts—Book & Paper from Columbia College Chicago, and currently teaches writing at the School of the Art Institute of Chicago.

ABOUT HAYMARKET BOOKS

Haymarket Books is a radical, independent, nonprofit book publisher based in Chicago.

Our mission is to publish books that contribute to struggles for social and economic justice. We strive to make our books a vibrant and organic part of social movements and the education and development of a critical, engaged, international left.

We take inspiration and courage from our namesakes, the Haymarket martyrs, who gave their lives fighting for a better world. Their 1886 struggle for the eight-hour day—which gave us May Day, the international workers' holiday—reminds workers around the world that ordinary people can organize and struggle for their own liberation. These struggles continue today across the globe—struggles against oppression, exploitation, poverty, and war.

Since our founding in 2001, Haymarket Books has published more than five hundred titles. Radically independent, we seek to drive a wedge into the risk-averse world of corporate book publishing. Our authors include Noam Chomsky, Arundhati Roy, Rebecca Solnit, Angela Y. Davis, Howard Zinn, Amy Goodman, Wallace Shawn, Mike Davis, Winona LaDuke, Ilan Pappé, Richard Wolff, Dave Zirin, Keeanga-Yamahtta Taylor, Nick Turse, Dahr Jamail, David Barsamian, Elizabeth Laird, Amira Hass, Mark Steel, Avi Lewis, Naomi Klein, and Neil Davidson. We are also the trade publishers of the acclaimed Historical Materialism Book Series and of Dispatch Books.

PRAISE FOR KRISTA FRANKLIN'S *TOO MUCH MIDNIGHT*

"Krista Franklin is for grown folks only. *Too Much Midnight* is a brilliant synthesis of her stunning and wildly influential visual art with a series of poems that wrench at the gut of you. This is truth-telling in the vein of Nelson Algren and Patricia Smith, poetry from heavy and dark places-- dark like blood, dark like midnight, dark like obsidian stone, like 'blue-black everything.'"

—**Eve L. Ewing**, author of *1919*

"There doesn't seem to be a word big enough for all that Krista Franklin is, what miracles she can make when tested with a blank page in front of her. The specificity of her sculpting, her ability to be witness, maker, collector, and knife to all our stories. *Too Much Midnight* is an exercise in precision, both the blade and the wound it is thrust in. Franklin imagines and re-invents, holding a magnifying glass to things most leave unsaid. Her language collages into and onto itself, leaving the reader in the middle of a whirlwind of words and images, demanding that they contend with it all. After this book, all other language feels weak."

—**Fatimah Asghar**, author of *If They Come for Us*

"*Too Much Midnight* is what happens when you cross Betye Saar and James Baldwin, Octavia Butler and Chuck D. Krista Franklin archives the battles and beauties of black life. Her kinships are familial ("Clifton, Brooks, Knight, Grandma & Grandpa Franklin..."), political ("Taking the Country Back: The Tea Party Pantoum"), and cultural ("Oshun As Ohio Players"). These superb poems and images synthesize intimacy and activism, passion and wonder. Franklin's artwork resonates like visual poetry, her poetry resonates like lyrical music. *Too Much Midnight* is phenomenal."

—**Terrance Hayes**, author of *American Sonnets for My Past And Future Assassin*

"What I love best about Krista Franklin's work is that I can never quite put my finger on why it's so affecting—*Too Much Midnight*, her newest volume, is no exception. Here, both the intangible and the concrete are given sublime quarter in exquisite collages, poems, and an interview with the artist-author that felt like a bonus track I would happily wait to listen to again. 'I am a weapon,' Krista Franklin writes in the opening poem—agreed! Here, there is patience and precision, dynamics and dimension. Part origin story, part call to arms, part gallery, *Too Much Midnight* testifies that it is never too late to be vivid, extraterrestrial, undeniable."

—**Tarfia Faizullah**, author of *Registers of Illuminated Villages*

"As practices of racial violence continue to organize themselves around multi-scalar human vulnerabilities, black creatives invent and reinvent infrastructures of liberation. In *Too Much Midnight*, Krista Franklin imagines blackness as the practice of moving through historically present plantation logics. Visually and textually, frayed histories, geographies, and narratives intersect with portals and polymers and integers and diamond film. Visually and textually, Franklin signals black freedom as a protracted archive of black livingness."

—**Katherine McKittrick**, author of *Demonic Grounds and Dear Science and Other Stories*

"*Too Much Midnight* is a juke-jointed collage of poetry, proclamation, portrait and paint. Franklin blooms each page into bellwether of blues. These 21st century hoodoo-drenched epistles scratch and pop across the memory like diamond needles in a galactic groove. When you fall face-forward through these verses, you'll roll hard with what she's reckoned: Here's a mirror. Look behind You, beyond You. Here's a portal. Jump through it."

—**Tyehimba Jess**, author of *Olio*

"What will be a greatest hit compilation for some & a superb introduction for others, Krista Franklin's *Too Much Midnight*, beautifully and powerfully displays how x-acto knife and pen are formidable tools to present narratives rooted and/or guided by imagination and purpose. The poems and visual works are fantastical prophecy more than worthy of examination and praise. This work unravels wounds as much as it haunts and lingers like whispers thick on the ear. Ms. Franklin is a wicked conjurer by way of the funk trunk that is Dayton, Ohio and her brew is a significant addition to the cannon of work that weaves blackness, womanhood and popular culture meticulously. In the words of the mighty purple one Prince Rogers Nelson, All the critics love her in New York! Bravo Sis!!!"

—**avery r. young**, author of *neckbone: visual verses*

"*Too Much Midnight* is a refreshing, and all-consuming text. Krista Franklin generously unfurls her dexterity and many gifts in the name of what might be possible by way of liberation and revolution. The text and images form an overwhelming tapestry of brilliance. This is work of uplift, of persistence, of dreams for a new horizon and a better world beyond it."

—**Hanif Abdurraqib**, author of
A Fortune for Your Disaster

"Krista Franklin's hands hold knife, pen, water, and oil—all precious things—with such skill that they can transform this shitty world into flowers. Too Much Midnight is a living arrangement that doesn't sit still on your table, but crawls through space remixing time and brightening our understanding of life."

—**April Sheridan**, Joan Flasch Artists' Book Collection, School of the Art Institute of Chicago

"Krista Franklin's poetry and artwork have stunned me into the next decade of this young millennium. There is nothing shy or demure about Too Much Midnight, from its critical framing as an album to its articulation of image by multiple means. Franklin's project embraces the poetic utterance as a sibling to the impulse of color and form to create a menagerie-experience that celebrates objects of personal and cultural narrative as artifacts of survival. As a long-time admirer and collector of Krista Franklin's work and sometimes collaborator with the artist, I am struck by the way she effortlessly gleans such vivid intensity from the everyday-ness of living, which is to say, *Too Much Midnight* takes living seriously. The poems and images here are not interested in a clear trajectory and, instead, explore the multitude of ways the reader, and viewer, travels from point a to point be, moves between 'the sight of angels' to 'the world ... burning.' We come to understand within these pages that Time is an illusion. Depending on the body that you live in and that history is slippery as memory. Franklin asks, where do we connect? And when? as she also, simultaneously provides the landscape wherein our connection is made possible. Expect to meet a myriad of souls within these pages."

—**Ruth Ellen Kocher**, author of *Third Voice*